The
Family
of Women

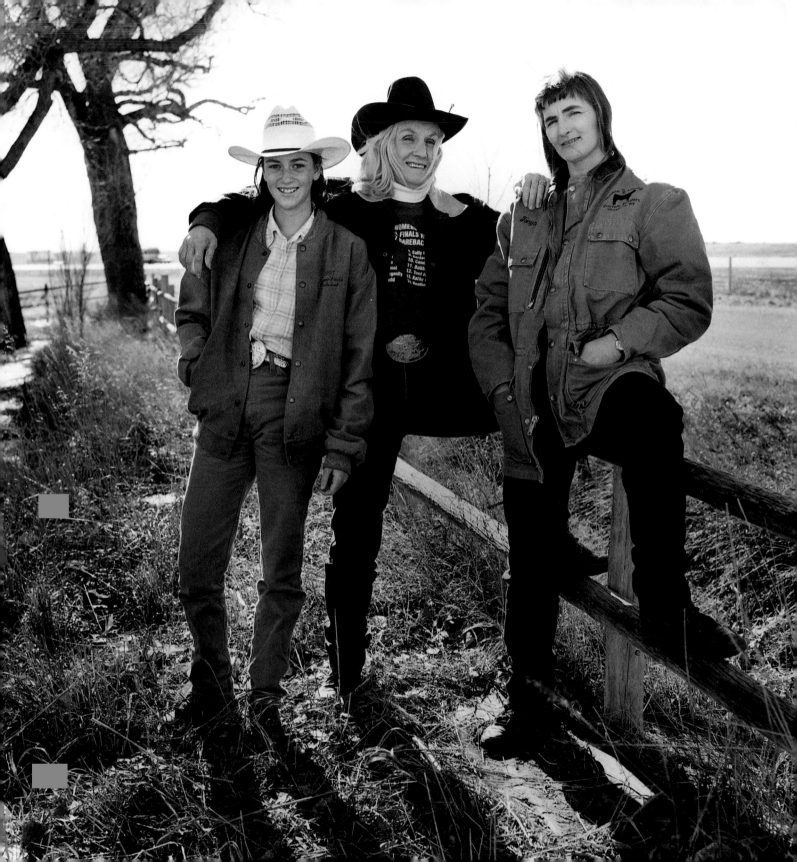

The Family of Women

Carolyn Jones

EDITED BY TODD LYON

Abbeville Press Publishers

NEW YORK LONDON PARIS

EDITOR: Jacqueline Decter

DESIGNER: Patricia Fabricant

PRODUCTION EDITOR: Meredith Wolf Schizer

PRODUCTION DIRECTOR: Hope Koturo

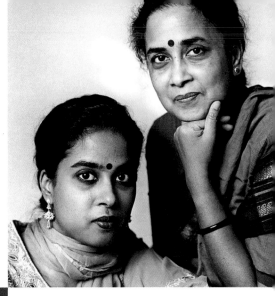

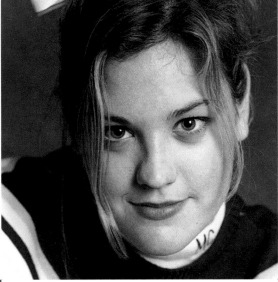

*For Zoe
and Mercer*

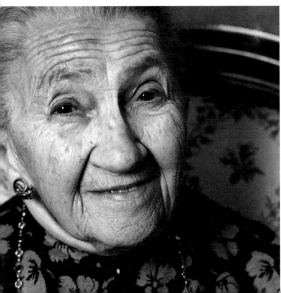

First edition
10 9 8 7 6 5 4 3 2 1

Library of Congress Cataloging-in-Publication Data
Jones, Carolyn (Carolyn Elizabeth)
 The family of women / Carolyn Jones ; edited
by Todd Lyon.
 p. cm.
 ISBN 0-7892-0338-3
 1. Women—United States—Biography—
Anecdotes. 2. Family—United States—
Anecdotes. 3. Biography—20th century. I. Lyon,
Todd. II. Title.
CT3260.J66 1999
920.72′0973—dc21 98-31560

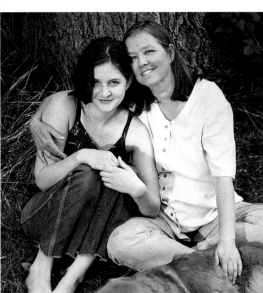

Introduction
7

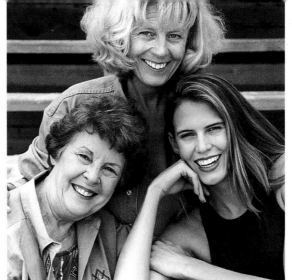

CONTENTS

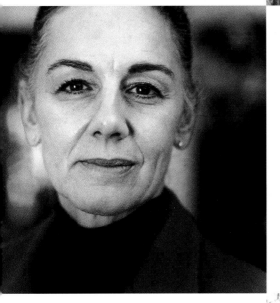

The Families
13

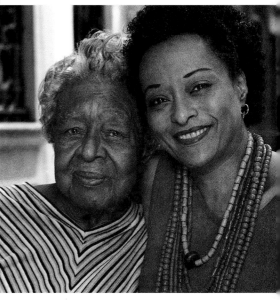

Jacket front, left to right: Renee Grier, Mehgan Heaney-Grier, and Beatrice Ann Nelson (see pages 22–25).

Jacket back: Gwen Bond and her granddaughter Emmy Laybourne (see pages 14–17).

Frontispiece, left to right: Tasha Stevenson, Jan Youren, Tonya Jan Stevenson (see pages 48–51).

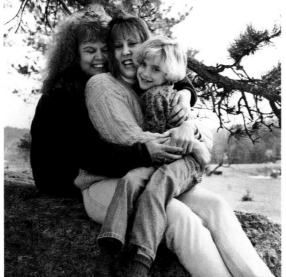

Acknowledgments
140

Index
142

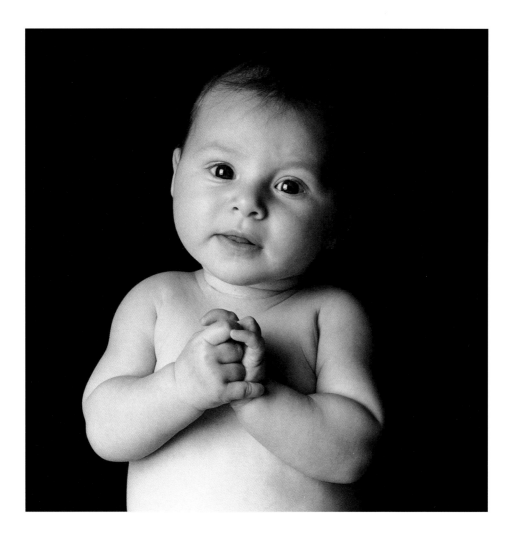

Introduction

I have always been more comfortable in the company of men. I remember being at my doctor's office when I was pregnant with my daughter Mercer. All the other pregnant women in the waiting room kept saying that it didn't matter whether they had a girl or a boy, as long as the child was healthy. I cared a lot. I wanted a boy. I wanted the less complicated relationship that a mom can have with her son. I wanted the adoration and you-can-do-no-wrong feelings a son often has for his mother. When I had my sonogram my husband was in the room with me, and the doctor delightedly told us that we were going to have a baby girl. I knew I should have cared only that she was healthy—but I wept. I knew that my feelings were inappropriate, but I was scared.

By that time I had been a stepmother for six years. I had refrained from sprouting the fearful evil-stepmother wart or falling into the jealous rage that leads to poisoning apples, and I had discovered that being a stepmother to Zoe had brought me amazing joy and delight. But the prospect of having a daughter who might be cut from the same cloth as I was? I wasn't prepared for that.

From the age of thirteen I knew I wanted to live in New York and make my own way. As soon as I graduated from college I left my hometown of Lancaster, Pennsylvania, for Manhattan. I went through my twenties looking for, and finding, challenges. I became a photographer. I loved my work. I fulfilled a lifelong dream of driving the Paris/Dakar Rally across eight thousand miles of desert. I was an aunt to four of the most wonderful nieces and nephews anyone could hope for. I thought life couldn't get any better. Then—boom!—I fell in love with a Frenchman who had a daughter from a previous marriage. When he asked me to marry him, to my complete surprise I had an overwhelming urge to get married in my mother's wedding dress in the Lancaster church where I had been baptized.

Mercer at four months

7

Shortly after I got married I began work on a book project that would ultimately change the course of my life. I had the privilege of photographing and interviewing seventy-eight men, women, and children living with AIDS. As this was before the life-prolonging "drug cocktails" became available, many of the people I photographed knew *how* they were going to die. Families that had grown distant rejoined. One man who had been at odds with his mother his entire adulthood made amends. I was struck over and over by how important family is and how very precious life is. Witnessing so many people dealing with and facing their own mortality so eloquently made me start to think about bringing a child into the world myself. Jacques and I decided to have a baby.

Until then, I hadn't had to face the issues that confront many working women. Zoe was six years old and already in school when Jacques and I got married. I had been able to continue with my work, and I had never experienced what it was like to have to leave a new baby to go to the office. When I was growing up, my mother had been there to greet me every day after school. And many of the women in my life had gotten married right after college and had had children soon after that. But I love what I do. In many ways I *am* what I do. I really don't know how *not* to work. Stopping work once the baby was born was not an option for me. I was desperate to find other women facing the same challenges as I was—women who had managed to continue their careers *and* raise their children. I needed to talk to their kids and find out how *they* felt. I needed role models.

Photography is my way of learning about things. It has always been my passport into other people's lives, my means of finding out how others live. So I thought it might be helpful to seek out women who were grappling with issues similar to mine and photograph them. I began to keep a file of articles about women who inspired me, women who had accomplished something or had faced adversity with great dignity. I remember reading a piece in *Life* magazine about Aimee Mullins. Aimee is a double amputee who runs on steel legs. I just kept looking at the photo of her in that article, trying to imagine what it would be like to go through life with that challenge. Was Aimee fundamentally different from me? What was it like for her mother? How in the world did she raise Aimee to face life with such spirit? I wanted to talk to her mother and her grandmother and find out what magical, secret, mysterious set of tools gave them the ability to deal with Aimee's disability so beautifully. I wanted to incorporate those tools into my own life. Aimee was one of the first people I photographed for

this book, and it was a great way to start the journey. I remember her mom looking at me and asking me why I was interviewing her—she thought the story was supposed to be about Aimee. She thought she hadn't done anything more special than raise her daughter the way she herself had been raised.

Soon I found myself talking to mothers, grandmothers, and great-grandmothers about conflicts and issues that they had had with their mothers as young women. I found commonalities that I had not expected. We are, after all, all daughters. The details may differ, but in each generation women struggle with breaking away and defining themselves, and you know what? Like me, many of these women chose different paths than their mothers had.

I had the opportunity to go into women's homes, sit in their kitchens, and ask them about important moments in their lives; then I would talk to their daughters, sisters, mothers, and/or grandmothers about the same moments. I wept in more women's kitchens than I can tell you. In Chicago I photographed Brenda Eheart, a professor at the University of Illinois. Brenda saw a problem with the way that her community dealt with foster children and came up with a bold, brilliant solution. Brenda's daughter told me that when she was in college she walked by a newsstand and there was her mom on the front page of the *New York Times;* she felt so proud. Peggy Shepard, who has devoted her life to public service in Harlem, has a daughter who was equally proud when Peggy was running for office. These young women showed me that giving our daughters a chance to be proud of our accomplishments is a gift.

I traveled to Wyoming to photograph "Grandma Jan" Youren. Together we drove to her daughter's ranch. As I listened to Jan during that three-hour drive through the Rockies, I thought that as different as our lifestyles are—and I mean these women were in a barn *welding* when we pulled up—we were not so very different from one another. You work, you look for happiness, and you try to raise your kids the best you can.

My assistant Chris and I spent a weekend on a Navajo reservation. We sat in a hogan while Mary Begay made fried bread and spoke to us through her daughter, who translated her words. Everything about the place was foreign to me—the texture of the land, the color of the sky, the floor of the hogan, and the smell of the sweet bread. I could not understand the language and yet I felt great similarities with these women. Their struggles were different from mine, and yet there were many common threads.

In South Dakota I met Arlette Schweitzer. I had read an article about her some years earlier and knew that she had given birth to her own grandchildren. But whatever preconceived notions I might have had about this woman went out the window when she said, "You know, I didn't ever know what all the fuss was about; it would have been the same if my daughter Christa needed a kidney." Arlette and I must have gone through an entire box of Kleenex as she told me her story. She must have thought I was crazy sitting there weeping while she opened her heart. How women can love! How deep their emotions run, how very complicated they are. What boundaries they are willing to cross, and what chances they are willing to take for their children.

One of the most powerful experiences on my photographic journey was meeting Aphrodite Tsairis, who had lost a daughter in the terrorist bombing of PanAm flight 103. I wanted to meet Aphrodite because she had taken her grief and made something positive come out of it. Not only did she effect changes in the way victims of terrorism are dealt with, but she created a foundation in honor of her daughter to keep Alexia and what she stood for from being forgotten. I was deeply grateful for the opportunity to hear her story and meet her mother and her surviving daughter, Ariadne. Women have the uncanny ability to take their hurt and pain and turn it into an avenue for helping others who have gone through something similar.

Throughout my work on this book I kept feeling as though I was bringing home little jewels of understanding. Various things that women all over the country said to me stuck with me, and I would come home and try to incorporate them into my everyday life with my girls. Insights, small gestures, day-to-day ways of dealing with life. Judy Wicks told me that she was always so happy to see her mom at the front door whenever she came home. I asked her mom how she had pulled that off, and she said that she never judged Judy, she always respected her decisions, and she *listened*. It seemed so simple, but I came away from that visit wondering if I was listening to Zoe enough, so I made a concerted effort to talk less and really try to find out about *her* life. Artist Betye Saar told me what it was like to make art with three little girls around her studio. Instead of separating the girls from trays of chemicals, she taught them what they could touch and what was dangerous, and she let them be a part of what she did. I have a darkroom in my home, and up until that moment my four-year-old daughter had not been permitted to set foot in that room. In retrospect I realize that she must have wondered what in the world went on in there. I came back from my visit and discovered that at age four Mercer was eminently capable of knowing

what she could and could not touch; now she can help me with wet prints. It is an activity we can do together rather than something that Mom does alone.

When I met Emmy Laybourne she told me that her grandmother Gwen Bond used to give her grandchildren a dollar for every line of Shakespeare they could commit to memory. Gwen talked to me about how important she thought it was for children to be involved in the arts. As soon as I returned to New York I took Mercer, then three years old, to the Museum of Modern Art. We spent the day looking at Monet's *Water Lilies*. I saw things in that museum through Mercer's eyes that I had *never* seen before.

For scheduling reasons it could not be helped that I was in Chicago photographing Dr. Evelyn ("Effie") Golden on the day that Mercer turned four. Here I was doing a book on mothers and daughters, and I had left my own daughter on her birthday. It broke my heart. It seemed to epitomize one of the issues I was exploring: how do we resolve the conflict of working *and* being with our children? As I was leaving, Effie took my hands in hers, looked me in the eye, and said "Enjoy being a mother." I realized on the plane ride home that I was *thirsty* for Mercer.

I had so many questions that I wanted answers to in making this book. But I learned that there are no big answers—there are only ways to make each day better, to treasure each day more. I had hoped that I would meet someone and say, "Okay, she's figured it out, I am going to do it *that way*." But no, each of us has to figure it out our own way. I wanted to come out of this knowing what the right things to do were. Instead I learned different things. I learned that whether or not we work our children are influenced by what *kind* of women we are. If they see us helping others they will grow up caring. If they see us fulfilling our dreams they will grow up having dreams. If we cherish them as children, they will cherish their own children. I realize that the women included here are some of the most extraordinary women I may ever have the honor to meet. And their daughters are opening even more doors. It is, I think, like a great filtering-out process of what works and what doesn't. In every instance I was impressed with the daughters, granddaughters, and great-granddaughters of the women I met.

I am so lucky to have Zoe and Mercer in my life. Of course it looks like Mercer and I are indeed cut from the same cloth, but I will use everything I have learned from the women in this book to make sure that I listen to her and that I don't judge her. Hopefully we can keep the lines of communication open so that if I *do* judge her— she can tell me.

When I think back to the apprehension I felt on the day I found out that I was going to have a girl, I have to marvel at how powerful this relationship has turned out to be. My feelings have no beginning and no end. I had no idea that I could love like this. I had no idea that I could be so enchanted watching someone learn to eat a popsicle. I had no idea that I would spend so much time overwhelmed with emotion. Whatever path the rest of my life takes and whatever else I am able to achieve, raising my daughters will always be the accomplishment of which I am the most proud.

Perhaps at the end of this journey, it is my own company that I have grown more comfortable with. I have a found a depth and complexity in women that is both mysterious and beautiful. I will always enjoy the company of men, but now I relish being a part of a whole. I cherish the ability to find common ground with other women, and I am prouder than ever to be a part of the family of women.

CAROLYN JONES
New York City
September 1998

12

The
Families

"We grew up thinking that women held up more than half the sky."

GWEN BOND, 1916

GERALDINE LAYBOURNE, 1947

EMMY LAYBOURNE, 1971

Growing up in rural North Dakota, Gwen Bond entertained herself and her five siblings by putting on shows; to her children and grandchildren she passed along her conviction that the arts mean everything. Her daughter Gerry Laybourne, a media pioneer credited with creating the cable channel Nickelodeon, now wants to do for women what she has done for children. Granddaughter Emmy has written and starred in several off-Broadway productions and is currently co-starring in her first feature film.

GERALDINE LAYBOURNE

My grandmother in North Dakota was an incredible businesswoman and politician. She had three daughters, who were funny, smart, and attractive. We grew up thinking that women held up more than half the sky.

My mother raised us very sternly. We were expected to do something positive in the world. Be creative. Be decent. I can remember, from the time I was three, her insistence that her daughters be independent. She had given up a career to stay at home, she wanted us to have what she didn't.

I was sandwiched in between two wonderful sisters—my older sister was perfect and beautiful, and my younger sister was brilliant and charismatic. My father made me treasurer of the family when I was five. I opened bank accounts for my other siblings, who I thought were incredibly irresponsible, and by the time I was sixteen I was running his office in the summer. Mother, on the other hand, had a rich creative environment for us. She would take us to plays and gave us painting lessons when we were five. She would turn off the TV set before the shows ended and have us make up the ending.

My family was so supportive that you almost didn't have any way to judge whether you were doing well or not. The result is that my mother has three daughters who are incredibly hard on themselves. We basically believe that if we don't drop in a heap at the end of the day, we haven't done our job.

I think I've been well served by a sense of humor and basic self-confidence. Maybe my biggest achievement is some kind of balance—the fact that I have been able to have a rewarding career and a really rewarding relationship with my kids, my siblings, my mother, the greater family.

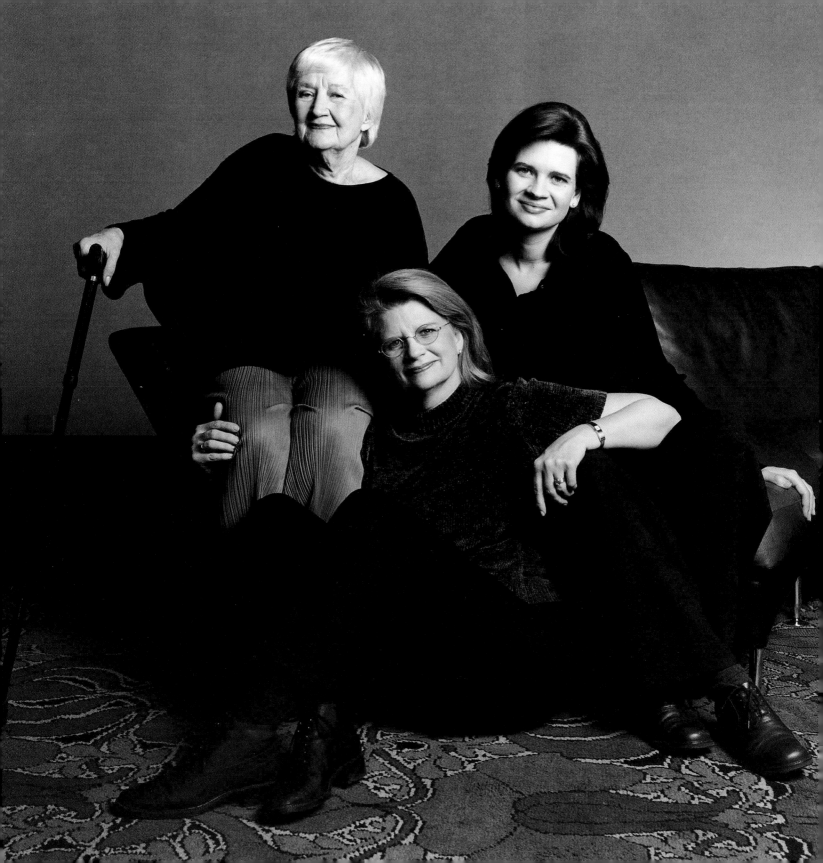

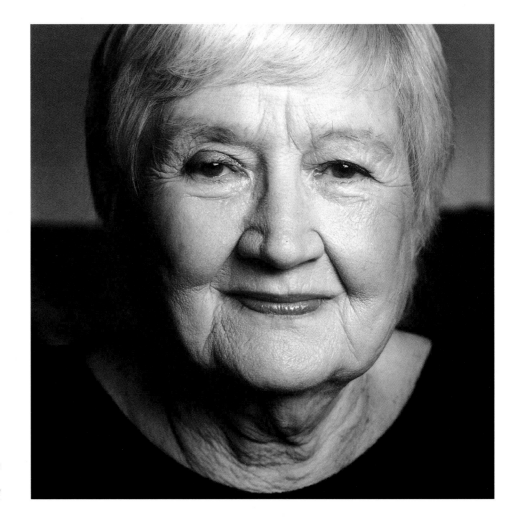

PAGE 15 *Left to right:*
Gwen Bond,
Geraldine Laybourne,
Emmy Laybourne

RIGHT *Gwen Bond*

GWEN BOND

The living conditions on the plains in North Dakota in the twenties and thirties were cruel—the blizzards and ice and snow of winter, the bruising heat of summer, the fear of the thunderstorms and lightning, the nine deadly drought years which wiped out hundreds of acres of wheat crops, and the infestation of grasshoppers that could sweep up a field of forty acres in an hour.

On my family's potato farm we couldn't count on a friendly environment for our crops, so we had to count on each other. My mother, Emma, and my father, Martin, raised six children, and we all helped them to raise us.

As children, we had to make our own entertainment. I directed shows with a cast of children, farmers, and farmers' wives from the Mounds in the Badlands.

When I went to North Dakota State University, there was a teacher who had come to bring theater and arts to the rural community. He passed on the message that there's something creative, useful, and worthy in most people—maybe all people. That became my belief above any religion.

The amazing changes in the world from my prairie theater to my daughter Gerry's media career to my granddaughter Emmy's stage and TV career!

Our first television came into our home in 1950. At the age of four, Gerry pulled a chair up close to our new Dumont TV. She placed a single rose in a vase and put on her best dress to watch *Hopalong Cassidy.* She left her chair to come ask me if I could swing her around and around to help her get *into* the TV set so she could participate in the show. This was our first clue about what Gerry would do with her life.

Some years later, Emmy gave me a clue to her future. At the age of two she sang to the birds at the Boston Aviary—loudly, huskily, and, I thought, beautifully.

It's fun to watch for clues and listen to each person. Clues are reliable. I am grateful that I can enjoy all the clues and signs about all the creative potential in all people.

EMMY LAYBOURNE

Grandma made me an actor. When I was a kid I had this introverted, bookwormy side and then this sort of weird, funny self that would come out occasionally. Grandma encouraged me to follow my crazier side. She did this with all the kids. She used to have us memorize lines from Shakespeare for a dollar. She had an award that she would give out every Thanksgiving to whichever grandchild had said the funniest thing that year.

We have such strong women in our family—a great tradition of women sticking up for themselves and sticking up for people around them. One of the reasons my mom has been so successful is because she finds out what people are good at and then she fights with everything's she's got to enable them to do it. She brings out the best and then she protects it.

What I learned from my grandma is to give everything away without fear. From my mother, follow your gut.

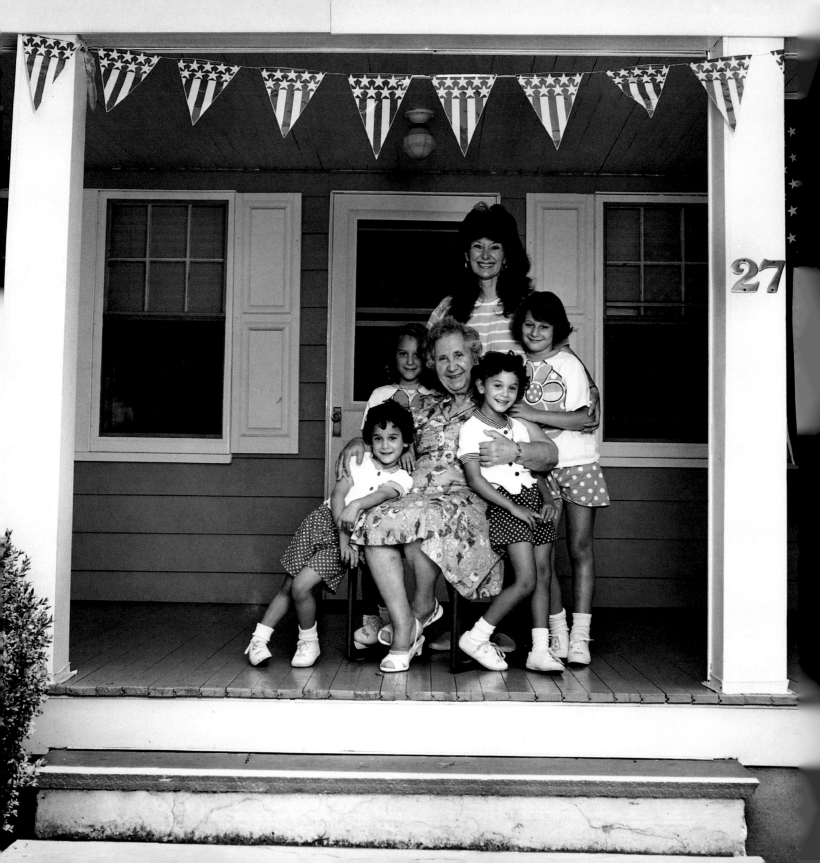

"These children may not have been born from under my heart, but they were born in my heart."

LILLIAN ALLEGRETTA, 1916

LINDA KUZLIK, 1950

ILONA ("LONI") KUZLIK, 1987

ANNA KUZLIK, 1988

MELINDA KUZLIK, 1991

KRISTINA KUZLIK, 1992

It was not possible for Linda Kuzlik and her husband, Ron, to adopt more than two children. They did not have the space or the money, and both worked full-time. Yet it was impossible for them to break up the family of four girls and one boy that they'd fallen in love with at a Hungarian orphanage.

LINDA KUZLIK

It's as if they've always been a part of me. I loved all of them from the second I laid eyes on them. Within twenty-four hours of our arrival in Hungary, they were calling us Mommy and Daddy. It was a perfect fit.

I had a son through my first marriage. He was three months premature, and I lost my second one at birth. I was forty when Ron and I met—he's fourteen years younger than me, six years older than my son. We wanted to adopt one and possibly two, if they were siblings, and we wanted children that were older, that were hard to place. So our attorney, Maria, showed us pictures of children from Hungary, and there were two little girls, four and five years old at the time, and I absolutely fell in love with them. We started the paperwork right away. About a month and a half into the adoption, we came across a picture of a boy and I said to Ron, "'What a handsome kid!" And Maria says matter-of-factly, "Oh, that's the brother of the two you're taking." And I said, "There's three?" "Oh no, there's five."

I spent six weeks in the orphanage, and I learned that these kids are inseparable. They hug, they kiss, they fight, they pinch, they do everything that normal brothers and sisters do. They lost their mother, they lost their father. Their grandmother, who they loved dearly, died.

Ilona—we call her Loni—remembers when her mother was pregnant. And she said right after Kristina was born, her "other mother" left. Loni was only five and a half. She fed the baby, changed her diapers, she cooked! She did whatever it took to keep her family together—Kristina, Melinda, Anna, Loni, Ron Jr. At one point the father locked them in the house for a week with no food. After two days Ron Jr. climbed out the window and begged the local baker for bread. Then Loni climbed out and picked carrots from the neighbor's garden.

19

I was heartbroken that they had to be separated and I said, "We're taking the five." And my husband almost had a heart attack. He said, "You are crazy, Lin. Think with your head. We are not in a financial position to take all five kids."

We went home and started writing letters. Then I made calls—Dial-a-Mattress, Sears. You would be surprised how much people want to help when they hear that you're doing something good. The children were not allowed to bring anything out of the orphanage, so we had to have complete clothing, head to toe, for five children.

Little by little, our community started coming together. Our neighbors bought our children bicycles, which they ride every day. I would come home from work and find bags of clothing, washed and ironed, folded neatly on our doorstep.

I work at the same company I've been at for eleven years, and my husband works full-time, too. During the day we have a Polish woman who came through our parish. The kids are picking up Polish words, learning English, and they're still keeping their Hungarian.

I'm not overwhelmed with having five children. I'm overwhelmed with the fact that there really isn't a lot of room in our house. But God has provided us so far with everything that we've needed, and I have faith He'll come through again. There is no greater joy in our lives than to hear the laughs and the screaming—it's wonderful to come home and pull into the driveway and have five kids running out all at once, "Mommy's home! Mommy's home!" If I never got another gift for the rest of my life I wouldn't miss it, because these are my five diamonds. Everybody says, Gee, these kids are so lucky. I think it should be reversed: We are so lucky.

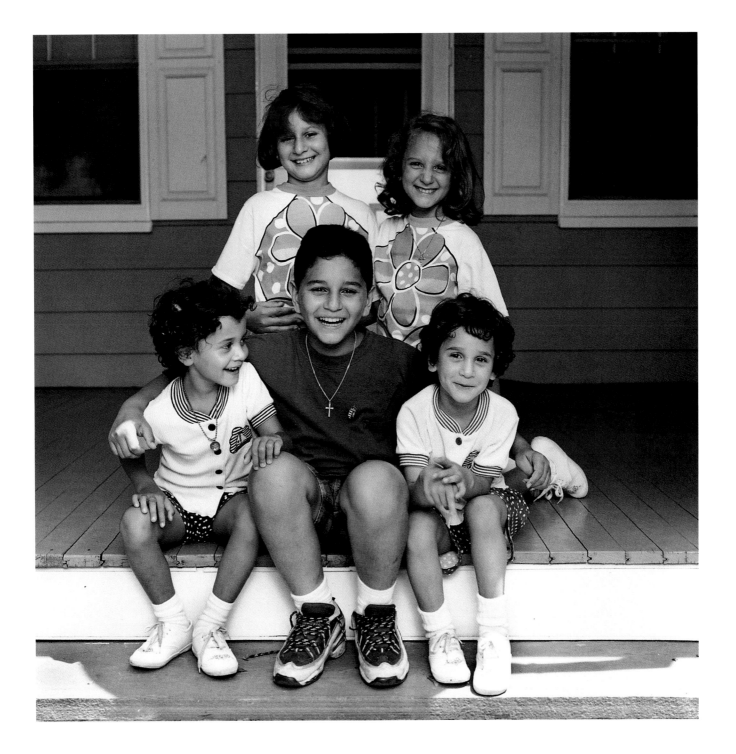

"I'm learning that being a mother of adults is as rewarding as being a mother of little children."

BEATRICE ANN NELSON,
1932

RENEE GRIER, 1953

MEHGAN HEANEY-GRIER, 1977

As a member of "Mehgan's team," Renee Grier's job is to cling to a diving platform with a tank of oxygen and wait while her daughter plummets nearly 200 feet underwater and returns to the surface—all on a single breath of air. Mehgan is a champion free-diver, and her dedication to the sport has centered a family whose early years were marred by strife and uncertainty.

MEHGAN HEANEY-GRIER

Heaney is my biological father's last name and Grier is my stepfather's last name. I've lived with my stepdad since I was eleven, so they were both my fathers.

When we moved down to Florida it was weird, you know, coming from Minnesota, but it was really exciting for me. I remember telling my dad, "It's going to be such a cool experience to just be around the ocean."

I was in seventh grade. The kids were very different down here. I was young, I was getting into trouble. And my mom kind of said, "If you get into trouble again you need to go live with your dad." And I said, "Okay, I got into trouble again, so I'm going to live with Dad."

One thing that I loved about Minnesota was that you could still be a kid. I mean, we'd go to school dances and go to a party afterwards at somebody's house, and you know, the parents were there. It wasn't like some big scandal going on all the time like it was down here.

After I graduated I moved back to Florida, got a job at a dive shop, and learned a few free-diving techniques. When I did my first real dive, I was told not to go past 60 feet. And I went to 87 feet. Next time I did 120 feet. That's when we all sat down and said, "Let's put a team together." That was sometime in the winter of '95–'96. I want to eventually get to the Women's World Record, which is 204 feet right now.

I have a great respect for the ocean. I've trained as hard as I can. I have the best team that I could ever get, between my friends and family. I have my mom on the medical support team, I have great captains out there running the boats. I mean, we've done all the precautions and after that I put my trust in God. I really don't get scared.

My mom plays such a huge role in my life. When I was diving she used to reach over and touch my hand and I'm like, "What are you doing? You're distracting me,"

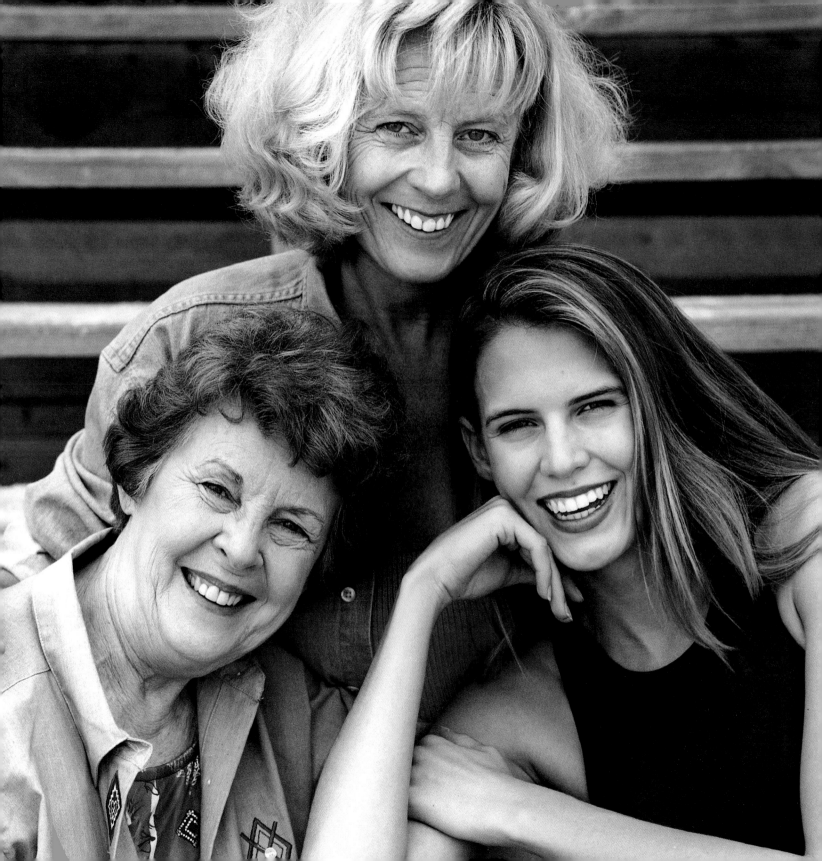

you know? "Oh, just in case anything happens I wanted to just touch you before you go." I'm like, "Mom! That's horrible!"

I've learned everything from my mom. I think one of the most important things she's taught me is to respect yourself. Confidence is so important because if you have low self-esteem it can lead to a disastrous cycle that just keeps going around and around.

We still have a mother-daughter relationship, but we also have a friend relationship, and it just gets better every year. It's really cool that she's on my team. It's like she's helped all of my dreams come true.

RENEE GRIER

I was married for a lucky thirteen years. Rather than stay in a bad marriage as I had seen my parents do, we opted to end it. It was hard being a single parent, but it was also a lot of fun. Three women together—three girls—we got to be very close. By the time I married my second husband we were kind of a formidable group.

We moved from Minnesota, where education is like fifth in the nation, to Florida, which is forty-eighth. It's a party atmosphere down here, there's a big drug culture, and I was frankly appalled. It wasn't uncommon for seventh-grade girls to dress in slinky little skin-tight dresses. Mehgan looked like she was nineteen when she was thirteen, and she wanted to party with the big dogs, so to speak. I worked in the high school, I was the sex ed teacher, I knew what *everybody* was doing. It scared me to death because I could see the road she was going down. So we decided that she would go back up to Minnesota.

To this day, it was the hardest decision of my life. And it was an absolute 180-degree turnaround. We became as close as any mother and daughter I know. She graduated one of the top kids in her class. I mean, she grew up.

Renee Grier (left) and
Mehgan Heaney-Grier

When Mehgan started diving, I was nervous. And yet I realized that she did indeed have a natural talent. What she does is breath-hold free diving. She has to swim down, following a line in the water, grab a tag, and swim back up under her own power. When you're down to 150, 200 feet, there's a tremendous amount of pressure on the body, and there's the danger of not having enough oxygen to get all the way

24

back to the surface. Which is why you don't ever do this sport by yourself. You have to have people stationed at different levels.

My mom isn't a swimmer and she gets panicky putting her face in the water, so this sport was beyond her realm of comprehension. But I have to give her a lot of credit, because she has never interfered with what I have or haven't done with the kids.

Mehgan's in a really happy place. She loves what she's doing, she loves the people she's with. It's a real neat feeling to look at this person and think, "Wow." It's like when you cut 'em loose on their bicycle without the training wheels for the first time and you can't be any prouder, you know? And it's great to have a friend that knows you inside and out.

BEATRICE ANN NELSON

I grew up on a farm. I didn't have a lot of friends, so I said I was going to have at least a dozen kids; I stopped at five.

Poor Renee! She was my first child, and since I had no siblings and didn't even do any baby-sitting, she and I had to learn together; she became my right-hand helper.

Beatrice Ann Nelson

My first husband and I were married twenty-six years, but there was a lot of abuse.

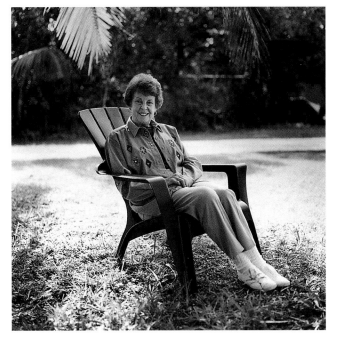

My biggest regret about staying in that marriage is that the children were put through a lot of heartache. Renee and my other daughter, Brenda, were instrumental in saying, "Mom, you need help." With their help I was able to get out of that relationship. Then I went back to school, got a job—I couldn't have done that either without moral support from my family—and I met Tom.

Mehgan was our flower girl. Even a grandma can have a flower girl at her wedding. I remember Tom saying, "Wow, two little words, 'I do,' and I not only get a wife, I get five children and four grandchildren."

In things that come up now, whether it's with business or family, we always say, "Well, we made it through the first twenty years, I think we can make it through anything." Renee and I both have survived a bad marriage. Mehgan survived high school. We're all survivors. I can't swim but I'm a survivor. And I'm learning that being a mother of adults is as rewarding as being a mother of little children.

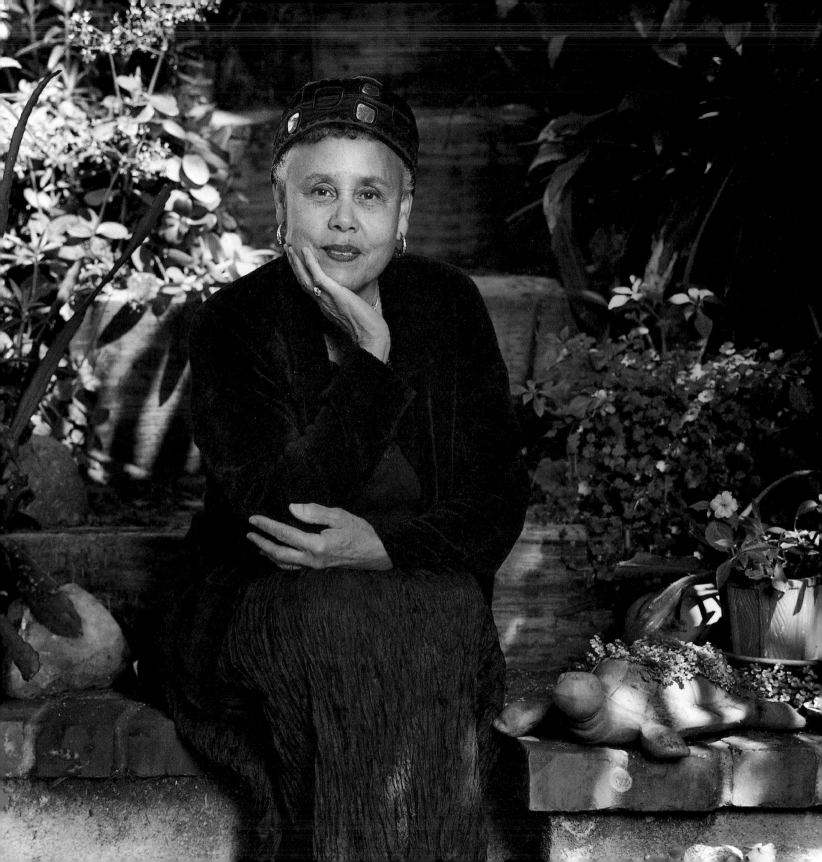

> *"My early prints were about my three girls. I wanted to make something beautiful and mysterious."*

BETYE BROWN SAAR, 1926

LEZLEY IRENE SAAR, 1953

ALISON MARIE SAAR, 1956

TRACYE ANN SAAR-CAVANAUGH, 1961

California artist Betye Saar brought her daughters up in a creative household where self-expression was encouraged. Alison followed her mother's path and became a multimedia artist. Tracye calls herself the black sheep of the family; she works as a censor for CBS television. Lezley resisted making art until she became a mother. Much of her work now addresses issues that surround her African-American heritage and the autism of her younger daughter, Geneva.

LEZLEY IRENE SAAR

We grew up in a creative, kind of bohemian environment in the Hollywood Hills. Both my parents are artists, and they were really affectionate and loving. I wanted to be anything but an artist! Maybe part of it was I didn't want to attempt art because I had a famous mother; I majored in communications and worked at a radio station.

Now I'm married and have two girls. Sola is eight, Geneva is six. When I was pregnant with Sola I started taking art more seriously. When she was born I think it opened my voice.

Sola was in the studio with me and I showed her a photograph and gave her the palette, and she did this great painting. I integrated it into the piece, and I gave her some money. From time to time I'll ask her to do one. It's not as if she wants to be an artist or anything charming like that. It's more like, "How much will I get?"

Geneva, my younger daughter, is autistic. I had a hard time accepting it. I think I cried for two years. But I like a lot of the weird things that she does, maybe because we grew up thinking it was good to be different. Autistic kids are really original and, you know, quirky. I stopped going to support groups because I would get depressed. Most of the parents want their kids to be normal. They don't see anything like I do. I look at the theater of the absurd, and that's life; it's in my living room every night.

I just hope for all autistic kids that people learn from them. Their approach is so different. Geneva taught herself the computer. She taught herself to read without any kind of logic. She jumps into the swimming pool, I'm freaking out, she pops up, starts swimming. This child has trouble putting a sentence together, all of a sudden she's showing me something. So I hope that by the time she is older, people just don't have them working at McDonald's or something; I hope they tap into that energy and creativity.

27

ALISON MARIE SAAR

The Canyon was very rural. We had dogs and guinea pigs and rabbits and a goat. And there was never a separation of the studio from the kids. We were always in and out.

I have two children. Maddy Leeser is four, and Kyle Leeser is eight. They're both very artistic. My husband's an artist, so we all do it together.

Art wasn't like a choice as a career or anything. In fact, I made a choice to try other things because my mother was getting a lot of attention. When I went on to graduate school I just decided to go ahead and become an artist—I took the old nepotism route! Definitely, I was being seen by dealers who wouldn't see me if I wasn't Betye Saar's daughter. Every once in a while we'll still get thrown together or confused, but that distinction isn't crucial to me anymore.

My work is really about the power of the individual and the power of the spirit. I think Lezley's work is about identity and my mother's also—there are similarities where the three come together, about African-American history and also about being half-black and half-white.

My great-grandmother was Irish-American, and she married a black man who was part Native American. My father is Scottish and German, and my husband is Irish and English. We gave our children Irish names because it was the only thing my husband and I had in common!

I want to have a social life, and I want to make art, and I want to travel, and I'm just finding that it's not possible to do it all. But being a mother . . . it's really wonderful to see this kind of spirit and soul come out of nowhere. Having children really taught me that the things I thought were crucial—whether you got a review or looked like an idiot on some video program—are nothing.

TRACYE ANN SAAR-CAVANAUGH

When I was little my relationship with my mother was more traditional, and when I graduated from college I worked as her assistant. I traveled with her

PAGE 26 *Betye Brown Saar*

BELOW *Standing, left to right: Sola Agustsson, Lezley Irene Saar, Alison Marie Saar, Maddy Leeser; seated, left to right: Geneva Agustsson, Betye Saar, Tracye Ann Saar-Cavanaugh*

to Southeast Asia and New Zealand. That's when we had a switch because I would be the one saying, "No, you sit down and have your lunch before you talk to this person."

I got my degree in journalism. When I first graduated I went to Otis Parsons, where Betye was teaching, and I studied graphic art. Now I work for CBS television as a censor.

I was the black sheep of the family because I had a job. We had this kind of like dilettante lifestyle. There was some kind of Bronte sisterness to us all: "We're off in Maine," and, "Oh, we're doing drawings and watercolors and letters." I was the one with the first real job, and I became *this* of all things. My mom and my sisters have gotten NEA grants—you know, "what is art" and "what is pornography"—and here I am viewing children's cartoons and discussing the viscosity of bird poop. But I remember having these discussions with my mom, and she's, "Well, on one level it is censorship, but a lot of creativity needs a boundary."

Within the last two years we've bought a house, gotten married, and had a baby. I always knew I wanted to be a mom. I think it's very important. Betye has a couple of girlfriends who never had children and I always thought there was a kind of sadness, like here they were admiring our family. That seems tragic in some sense.

BETYE BROWN SAAR

My mother was quite beautiful. There was a kind of female sweetness about her— like a gentlewoman—that I'm really pleased to say my daughters have. She always made things for us, she took us to plays, and in the summer we all took craft classes.

I studied design at UCLA. After school I became a social worker. Then I got married and started my own family. I made cards, I designed clothes, then I took a class in printmaking and that was the switch from graphic arts to fine arts. My early prints were about my three girls. I wanted to make something beautiful and mysterious.

My house was small and there was a sunroom that had been glassed in and that was my studio. We worked together. I was always proud to be a kitchen artist.

My greatest achievement, which I bless every morning and every evening, is my beautiful daughters. They're so smart and they're so healthy and they've made good marriages and they have lovely children.

Being a mother changes your life through love. Being a grandmother I get to experience that again. When their bottoms are soggy and they just give you this big, slobbery smile . . . just the way a baby feels in your arms, that's really special.

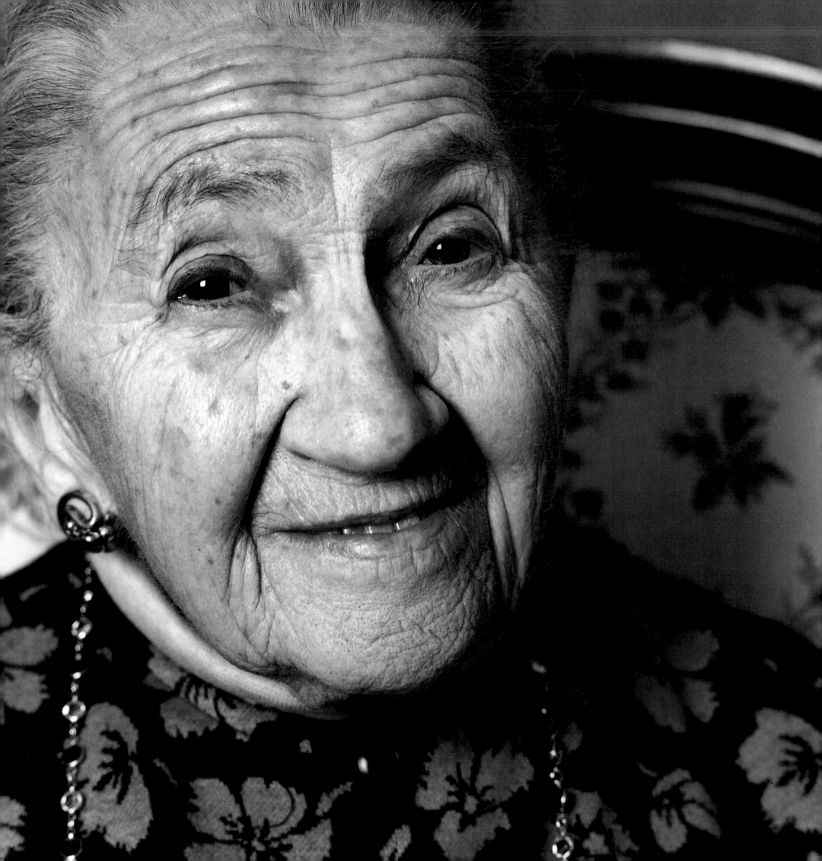

"Under the microscope I saw the…culprits that took the lives of my four brothers.… I knew the path I wanted to take."

EVELYN ("EFFIE")
GOLDEN, M.D, 1913

DEBRA GOLDEN-
STEINMAN, 1950

REBECCA STEINMAN, 1985

TAMARA STEINMAN, 1986

REANNA STEINMAN, 1992

Effie Golden grew up in a loving family with her parents and two siblings. But she was haunted by the tragic deaths of four brothers. Her parents inspired her to lead a life of selfless dedication to community and family; her brothers inspired her to spend a lifetime seeking cures. Her giving nature is evident in her daughter, Debra, who gave up a career as a speech pathologist in order to be a full-time mom.

EVELYN ("EFFIE") GOLDEN

My mother and father both came from Lithuania. It was the terrible time of the pogroms, and my father's parents felt that he would be killed or kidnapped for the Russian army. They sent him with some neighbors who were going to America. My father had his bar mitzvah ceremony on the boat.

My mother came with her parents when she was twelve. They traveled steerage and carried their most valuable possession, a big samovar—a tea urn. That was the most important thing in our home, because life revolved around drinking tea and telling stories.

My father got a job in a shipping company. My mother got a job sewing in a sweatshop. Eventually they both moved to Milwaukee—both of them had relatives here. They met and she fell in love with him, he fell in love with her.

They were married in 1900 and had four sons. In 1909 there was a terrible diphtheria epidemic—no immunization. These four children died in three weeks. The hearse just came back and forth. I don't know how my mother and father survived. They had the courage to start another family—my sister, my brother, and me.

They did not talk about the boys when we were growing up. Never once. I recall going up to the attic and finding old clothes, boys' clothes, and I had wondered why my mother was saving old boys' clothes. My aunt came to visit and told us this sad story and said it was a secret, and not to ask my mother or father about it.

I was influenced by this tragedy. Often when I held each of my six children in my arms, I would think, What would I have done?

At the University of Wisconsin I had my first contact with science. One day under the microscope I saw the diphtheria bacilli, the culprits that took the lives of my four brothers. I looked at that slide for a long time; tears rolled down my face. I knew the

path I wanted to take. My master's degree was in bacteriology and then I went on for my medical degree. After seven years of college and medical school I came to Flint to intern at Hurley Hospital, and I met my husband. He was in internal medicine and cardiology. He, too, was born in Lithuania and came from a large family. He was just wonderful, and an excellent doctor.

A good education was very important to my mother and father. They were determined that we would all go to college, and we did. My sister is now eighty-seven, the oldest woman lawyer in Milwaukee.

My father was very active in community work. His philosophy was simple: each person has a responsibility to help and care for those who need help. Give money or give your time, your energy, your creativeness, or give both. He was my role model. His philosophy became my philosophy.

My mother taught me how to be a mother. She was so kind, so lovable. She devoted her whole life to family and she would give everything to be with us. We were brought up with tender loving care.

DEBRA GOLDEN-STEINMAN

I look up to my mother for everything. Wherever I go in Flint, people tell me about my mother, and it just makes me feel so good. She does so many nice things for people.

Sometimes stories that she has shared with me I'll share with my girls. And some things I pass along, like education, how important it is. I'm always stressing that to my girls. "*After* you go to college, *then* you'll get married, *then* you'll have children."

Three of my children are adopted. My oldest, Rebecca, is adopted; Tamara's my biological child; Jacob we adopted from Guatemala. Reanna was our foster child, and just within the past month we adopted her. Saturday at our synagogue she's receiving her Hebrew name and we're having a big luncheon in her honor.

I was a speech pathologist before I became a full-time mom. I wouldn't change it for anything in the world. I love being with my children. I'll tell you, when I put my arms around them I'm just so thankful that I have my family.

My kids keep saying, "Why don't we adopt another one?" We're open. If somebody called on the phone right now and said, "We have a child," I'd go for it. There's always room for one more.

PAGE 30 *Evelyn ("Effie") Golden, M.D.*

FACING PAGE *Clockwise from top left: Debra Golden-Steinman, Effie Golden, Rebecca Steinman, Reanna Steinman, Tamara Steinman*

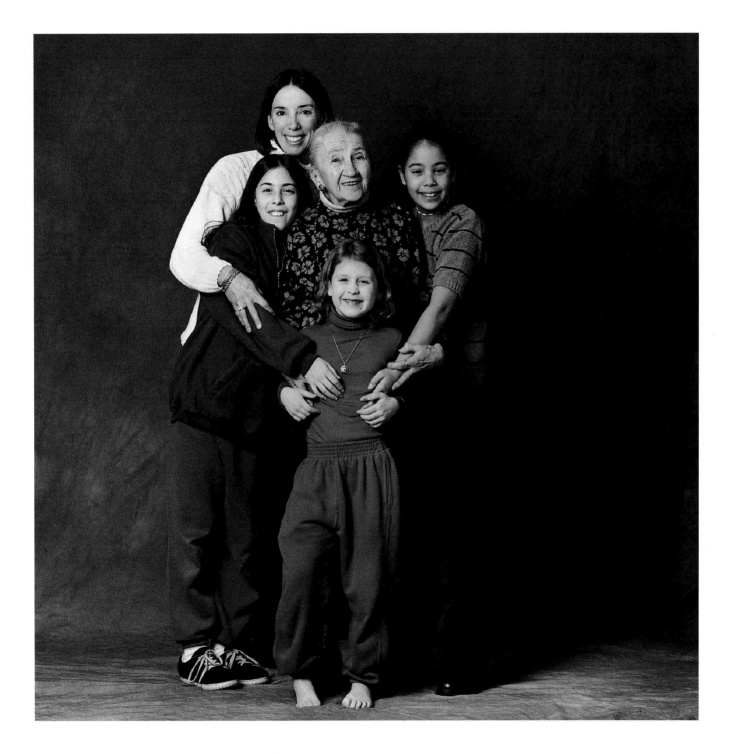

"I want to do projects that challenge people's idea of beauty."

CHRISTINE ANTHONY,
1917

BERNADETTE MULLINS,
1945

AIMEE MULLINS, 1975

Aimee Mullins is a scholar, an athlete, and a model. She's also a bilateral amputee. But her mother, Bernadette, her grandmother Christine, and eight aunts brought her up to believe that she was not disadvantaged. She's already set records in college-level track; now, says Aimee, "I want to do projects that challenge people's idea of beauty."

AIMEE MULLINS I was born without a fibula on both legs. My toes were turned in and I had two on one foot, three on another—they were webbed and deformed. I could not support my body weight, and the doctor said I would not walk, that I would be in a wheelchair the rest of my life. I was amputated on my first birthday. I learned to walk, run, bike, ice skate just like everyone else because I was so young. When you're young there is no notion that you cannot do something. You know no limits.

BERNADETTE MULLINS We were unprepared. I lost faith in the doctor because he told me everything was fine. I was worried about her—what would become of her. She was a beautiful baby.

AIMEE I was amputated below the knees. This is key because with knee functions, the only joint I don't have is my ankle. Just walking down the street you can't tell because I have knees.

BERNADETTE In kindergarten for show and tell, her first one, she took off her legs. She wanted to prove that they were not wood. That was Aimee. No one knew she was going to do it.

AIMEE I was fine until I hit puberty. I became more aware then, but I was always the class clown. I had the best grades, but I'd do anything to get a laugh. Sixth through ninth grades were awkward. Those years are hard enough as it is, but going through body image-identity and finding friends leaves a question about what people really think about you. My parents encouraged me to be self-reliant and try all sports—try what ever I wanted.

BERNADETTE Her attitude was, it's not my problem, it's theirs. She has educated us and taught us our shortcomings.

34

AIMEE People say, "What should I call you?" I say, "Just call me Aimee." "Handicapped" is definitely out. Some of these words serve as a way to separate us from normality.

CHRISTINE ANTHONY Aimee doesn't feel sorry for herself. She just gets on with it.

AIMEE I am lucky to have such a large, supporting family. There was always a get-together, and there was always a section hooting and hollering in the audience. What I find most special about my family is their ability to give. From my grandmother, I got strength. The woman absolutely embodies it. Every once in a while I stop and look at her and realize everything is because of her. All these people are here because of her.

PAGE 35 *Aimee Mullins*

RIGHT *Front row, left to right: Bernadette Mullins, Christine Anthony, Aimee Mullins; surrounding them are Aimee's eight aunts*

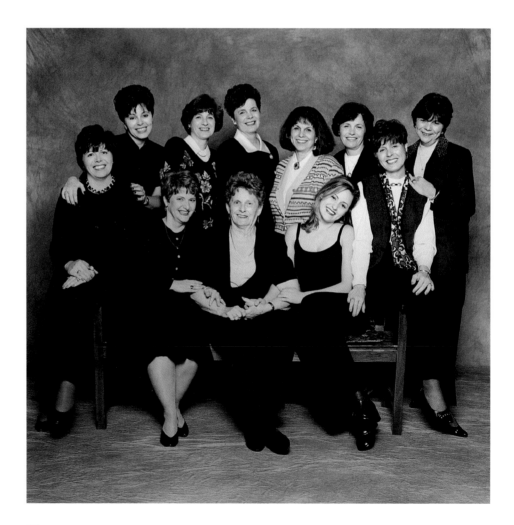

Aimee Mullins

She is so cool. She did some modeling when she was sixteen; she was a stunning woman and apparently my grandfather was the catch of the town. She got married and she had all these children.

CHRISTINE I got married very young. My mom didn't approve. There was no turning back. I couldn't come home and complain or anything. I tried to make it work—make it a home. There was never a dull moment in my life. I worked, even with eleven children. I worked in factories. There was a time, after my tenth child, that I had two jobs.

AIMEE Grandma is one of the most amazing things that's happened to me. The woman has paid her dues. If there's someone who knows the whole story, it's her. She had nine girls. Nine. God definitely knew what was going on when she had all these kids. Now we're all here, and everyone is successful in their own right, and they're all so smart and all do different things. We've got something for everyone—doctors, lawyers, a chiropractor . . . now we need a dentist.

BERNADETTE We are not a perfect family by any means. But there is a network. We are all there for one another. Love and friendship are what I got from my mom, and that's what I am trying to pass along to Aimee.

CHRISTINE Never be ashamed of your background and who you are; that's what I tried to teach my children. And always give your best—don't be a quitter.

AIMEE If you had told me when I was in high school that I would be in *Life* magazine or get to do some of the things I've been doing, I think I would have flipped. Now I think that anything's possible.

37

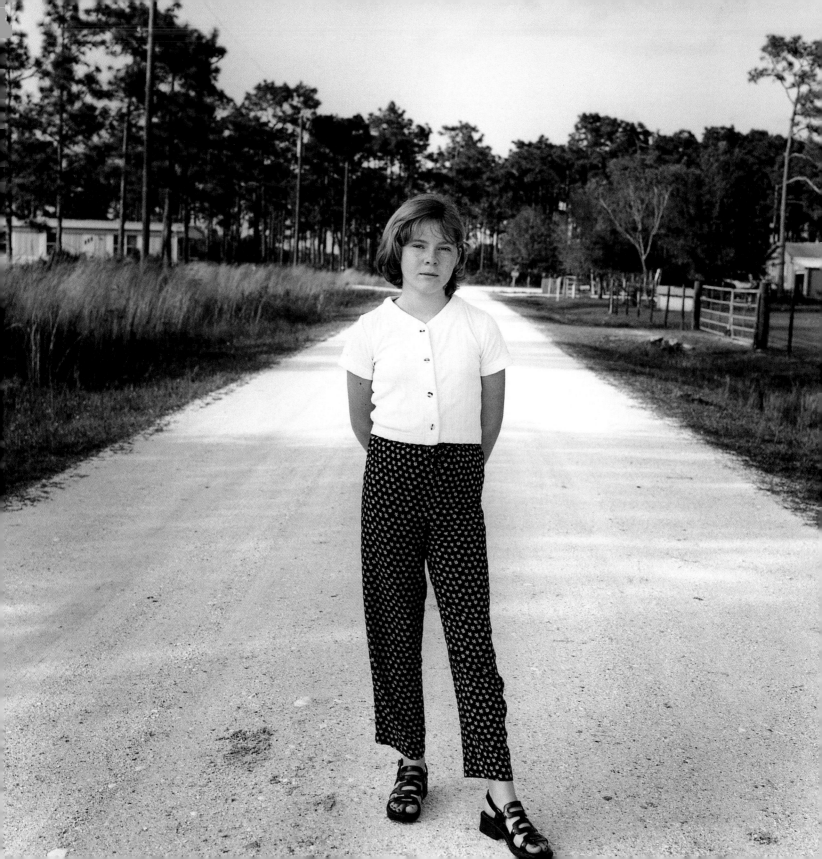

"Only in letting go can you hold 'em."

BARBARA HARRISON,
1932

TAMI O'STEEN, 1957

TARON STEPANSKI, 1986

Taron Stepanski's young life was repeatedly disrupted by dramatic kidnappings, court orders, and the clashing wills of two parents in two states. Yet through it all she has been loved and desperately wanted. Now, at the age of twelve, she is taking control and making decisions about her own future.

TAMI O'STEEN

Taron's father was my third husband. From the very first day that I found out I was pregnant, he paced the floors. She's the only child he has. I already had three kids.

We basically had a good life, and Taron was very loved, as she still is. My other daughter was fourteen when I had Taron, so in the beginning she resented Taron real bad. And she and Tim got to where they despised each other. They would fight, and there was no winning because I was not going to pick between my child and my husband. I left after I could not stand it anymore.

I came to Florida. I was down here like two months when Tim came and snatched Taron. She was almost four. He left me a letter telling me that he just couldn't live without her. But he never gave me an address or a phone number. I didn't know where he was living.

In August I found him in Texas, and I told him I was taking Taron out to eat, and when we got in the car she wrapped her arms around me and said, "Mommy, steal me. Steal me now, Mommy." So I did.

The following Monday I went to an attorney, and I got temporary custody. Five days later Tim came and stole her again. Well this time my sister and I were right behind him. When we got to Texas the law officers would not assist me. They told me my papers were not any good.

Two years later I got my daughter back with the very same papers. The only thing different is that Mark Miller from the American Association for Lost Children was standing beside me.

Those were the worst two years of my life. I probably cried a river. Taron got to talk to me five times on the phone. But every time he was standing right there. She could never tell me where she lived. And on Mother's Day of 1992, she called me and

said, "You know what, Momma? When I get really, really sad, I just lay down, and I stay real still, and I close my eyes, and I can see you." It just broke my heart.

When I got her back, you would not believe the shell that little girl was in. But her grandma told her the same thing she told me as a child: "There's a little Taron inside of you. And you make sure that you take care of that little Taron." Taron is real open now. I mean, she can express herself.

When she first told me she wanted to stay with her daddy for the summer, my heart just fell on the floor. She was seven. And I was like, "Taron, you're still so little, and I don't want anything to happen to you." And she looked at me and said, "Momma, I know my grandma's phone number, and my Aunt Lori's, and my Uncle Doug's, and my Uncle Craig's. If you don't let me go see my daddy, it's not my daddy that you don't trust, it's me."

She stays with me for the school year. Then she's on the plane to Texas for the summer. Now she wants to try the seventh grade with her daddy. I said, "I sure hope I don't have to fight for her again to get her back. Because this time I'm not going to have pity on anybody."

The first time, I could have had them extradite Tim. But my poor daughter had already been through enough. I came from a broken home, and I saw my father behind bars, and it does not feel good. And in the end, she probably would have resented me. I don't want her to ever say, "I could have had this time with my daddy, but you took it away from me." I want her to be happy. And I don't ever want her to hurt anymore. I think she's hurt enough.

Every year we have a benefit for the American Association for Lost Children. We have karaoke, volleyball tournaments, face painting, whatever. But there's no way I could ever pay Mark Miller back. There's no way, because my daughter has no price.

BARBARA HARRISON

I was born in the Depression, and my mother's parents had a farm that my dad paid off. He figured we could all live off the farm, and help each other. When my mother found out she was pregnant—I was her third—she tried to abort me; then she tried to kill herself. And when I was three years old she beat me pretty bad. My dad promised that I would never be left alone with her again, and I went to stay with my older sister. As I grew up I knew that a lot of what my mom did was mental illness.

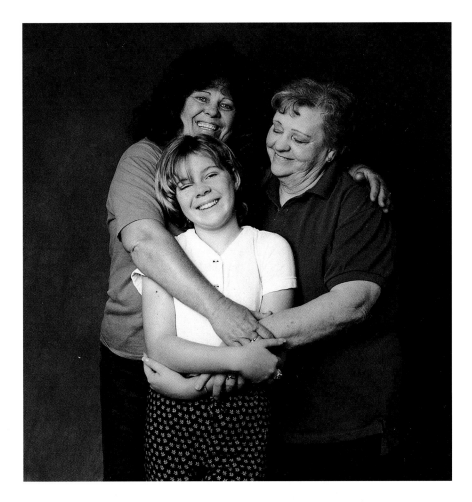

God excuses her, and we excuse her. But from my dad and my sisters and my brother, I had all kinds of love.

I remember my grandma telling me when I had my first son, "They're yours to have, to hold, and to love, and then let go." And it's hard to let your kids go. Tami is very independent . . . Only in letting go can you hold 'em.

I had a good time raising my kids. I think that's why we're so close. The only problem is, now they think that they're the parent and I'm the child. "Mom, you shouldn't be out after nine o'clock at night." I get a kick out of it. I tell 'em, "What do you want me to do? Sit here and wait for you to call? You're crazy!"

TARON STEPANSKI

I remember when I was riding my tricycle with my cousin and my brother, and my dad pulled up in a car, and he took me. But before that, he called me on the phone and said, "Taron, do you want to see me?"

ABOVE Clockwise from top left: Tami O'Steen, Barbara Harrison, Taron Stepanski

I said, "Yes." I thought we were just gonna visit, or something. And he came and said, "Let's go for a ride." And he put his hands out, and I put my hands up for him to pick me up, 'cause I didn't know.

We went to a hotel for the night, and Dad told me, "You're gonna live with me for a little bit." I didn't think it was wrong. I missed my mom, I got to talk to her a couple of times, but I just thought that it was, like, a vacation.

When I'm with my dad I miss my mom, and when I'm with my mom I miss my dad. I just wish I could have the both of them. I'm gonna be sure whenever I do get married, that the man I marry is one that really wants to spend the rest of his life with me.

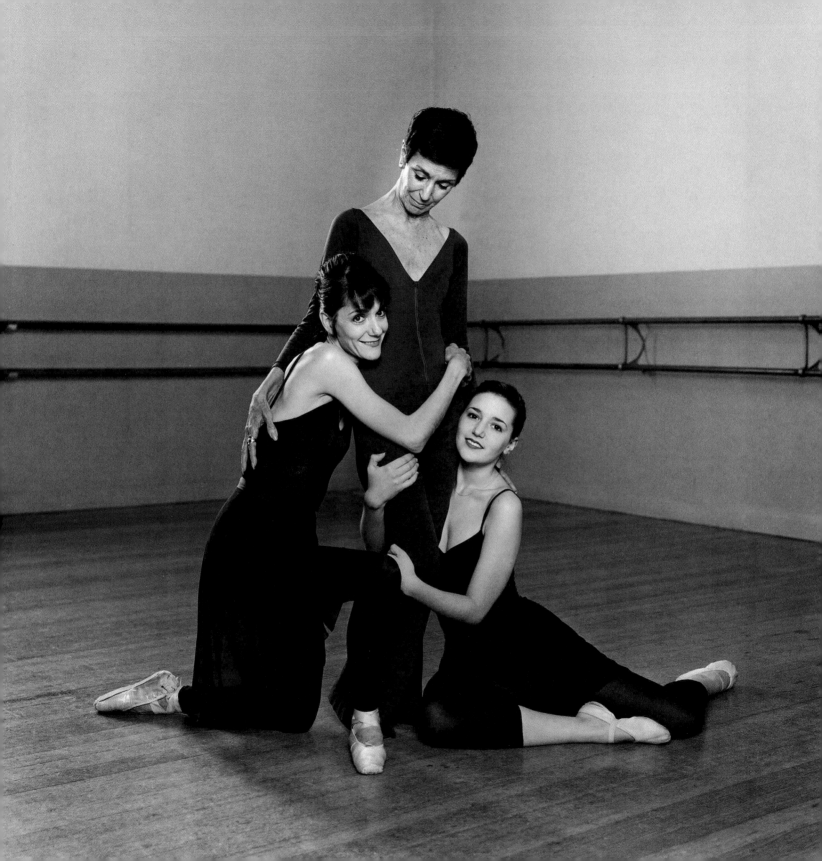

"My grandma said, 'Artistically you have a soul. Just make it show.'"

ANNE CAPOZZI BENA,
1932

ROSINE ANNE BENA,
1951

ANANDA BENA WEBER,
1981

Rosine Bena, prima ballerina, grew up in a dance studio under the exacting eye of her mother, master teacher Anne Bena. Rosine spent much of her life—on and off stage—leaping into the arms of Romeo or Prince Charming. Her only child, Ananda, has been given the same intense training, but is learning to express herself differently.

ANNE CAPOZZI BENA

I started to study ballet at age twelve and I was professional at sixteen. I had a hunger. I was very serious and very intense about my work. It's the only thing I ever wanted to do.

I was out of high school less than a year when Eddie and I were married. I was dancing at the Metropolitan Opera and teaching in Harlem, and I began to realize that the classroom turned me on more than the stage. My mom opened the ballet school for me. When Rosine was born, I had just turned nineteen, and I had my own business before I was twenty.

I always knew Rosine was gifted. Always. I have movies of her at age three where she would run up to her father and say, "Lift," and Eddie would lift her up, and she'd say, "Turn"—I mean, she was choreographing. She of course wanted to study right away.

The first time I saw her dance at the Washington School of Ballet, she was just unbelievable. I said to her, "Now listen very carefully because you're never going to hear this from me again. I am so proud of you. I am overwhelmed with what you're capable of doing." And she said to me, "Why am I never going to hear it again?" And I said, "Because from here on in, honey, I expect it."

Eddie and I were celebrating our nineteenth wedding anniversary when we learned that Rosine had made the Stuttgart Ballet. I said to her during the toast that night, "I hope you do better in your career than I did in mine." And my mother looked at me and said, "And I hope she does as well."

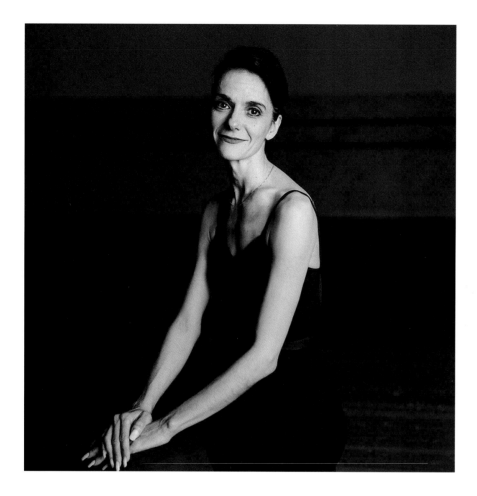

ROSINE ANNE BENA

I danced out of the womb. When I saw my first ballet, *Giselle,* I was three and I said, "I'm going to do that part." When I finally did it, I stood behind that door—Giselle's entrance—and my whole life flashed before my eyes.

I did my Giselle again when I retired in 1992. I thought I was handling it beautifully. I didn't have a nervous breakdown. I was fine. Afterward the costumer came to get the costume and I could *not* let go of it.

Occasionally I'd think, "What would happen to me if I couldn't dance? I might as well shoot myself." And so before I retired I went into therapy. Luckily I have a daughter, and she is so wonderful that there wasn't even a question of being miserable. Being a mother is definitely the best role I ever played. That was like a gift God gave me.

I always admired my mother. I thought she was very beautiful, just gorgeous. She was also really tough. She was much harder on me than anybody else, but she knew what I was capable of. And I knew when my mother said I was good, I was good.

I was the first American female to make the Stuttgart Ballet. And I remember running down the streets in New York, feeling like the world was at my feet. And then I went, and well, it was a flop. I had never been away from home, I didn't speak the language, everybody was older than me, and this person is sleeping with that person. . . . I resigned after two years.

When I was nineteen I came to California with my parents and decided I didn't want to dance anymore. Then a friend gave us a ballet that he had choreographed.

ABOVE *Rosine Anne Bena*

PAGE 42 *Clockwise from top: Anne Bena, Ananda Bena Weber, Rosine Anne Bena*

And my mother said, "Would you dance it?" I loved the piece and before you know it I'm dancing again. And then she says, "Let's start a professional company."

She started it with nothing. My father designed our sets. We got a board of directors, dancers, we ended up getting great reviews and having a really fine company for twenty-four years.

My mother gave me the guts and courage to do things that nobody else would ever dream of doing. I started a dance program in the public schools. It was sort of insane. I had to meet with all these macho coaches and tell them why a little ballerina thought that the program would be great. Well, I sold them, and I taught eight hundred kids a week by myself. I'm my mother's daughter. Some of the at-risk kids, you just can't believe the results. Dance answers something in people that a lot of times can't be answered in other ways.

If you ask me how I feel, I can't say anything. But when I dance it, it comes out. So I guess dance has given me everything. It's also given me a great love life because how many women could have so many wonderful lovers? You don't have to do their socks, you don't have to cook, you just meet Prince Charming every night, and then that show's over and you have Romeo.

Ananda's dad runs our tap program. He was my first husband; we were together for fourteen years. Then I married a building contractor, and that lasted six years. And then I married somebody within three months of meeting him. It was right after my dad died, my mom was a basket case, the school was not making any money. He was very romantic, but why I married him I'll never know. Ananda got a real taste of what terrible men are like. But my father, thank God, was a really great man.

Anne Bena

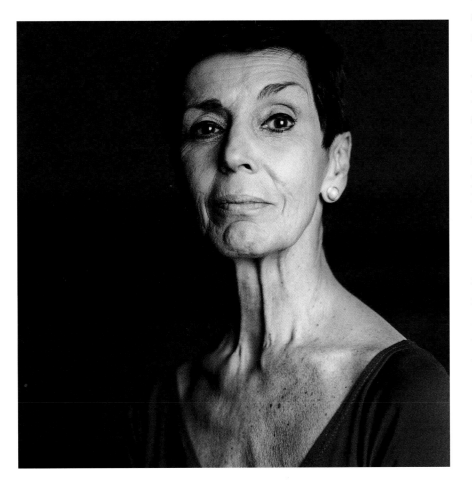

45

Ananda's name means "bliss." When she was a baby she'd sit in a little jump chair in class, and when we finished each combination you'd hear these little claps, "Bravo, bravo."

Now she just did the lead in *Damn Yankees*. She was fabulous. I cried through the whole thing and afterward couldn't speak, and my mother was like, "Are you going to live through this?"

You know, my daughter's much smarter than I am. Ananda's really, she's like my mom.

ANANDA BENA WEBER

My whole life I sort of idolized my grandma. When she walks into a room, I've seen grown men cry. She has this incredible walk. Her neck is so long—she's got two extra vertebrae—and she'd raise one eyebrow . . . she just creates this whole aura around herself that's mysterious and sort of provocative.

I never had a good body for dance. I have short Achilles tendons and my hips are uneven, my knees are uneven. I'm a good dancer, but I'm not anywhere near as good as my mom is, and I never will be.

When I first realized how tough it was for me to do certain movements, I sort of mourned. It was like a part of me died. But now I'm better because I find that there are other things I can do, like acting and musical theater and flamenco, so that's really becoming my passion.

If it had just been my mom and my dad teaching me I never would have stayed with ballet because of my body. My grandma said, "Artistically you have a soul. Just make it show." And I took her character [dance] class and for the first time I really learned how to express myself. My ballet class, my home life, my personality, I could control them, and she really taught me that. And I use that in acting, I use it in everything.

As I was growing up I found myself sort of taking care of my mother emotionally. It's a different relationship in the classroom. I call her "Miss Bena" and I think of her as my teacher, I respect her as an artist. It was my responsibility to make sure that she was on her pedestal, you know? Beautiful ballerina, Miss Bena.

Ananda Bena Weber

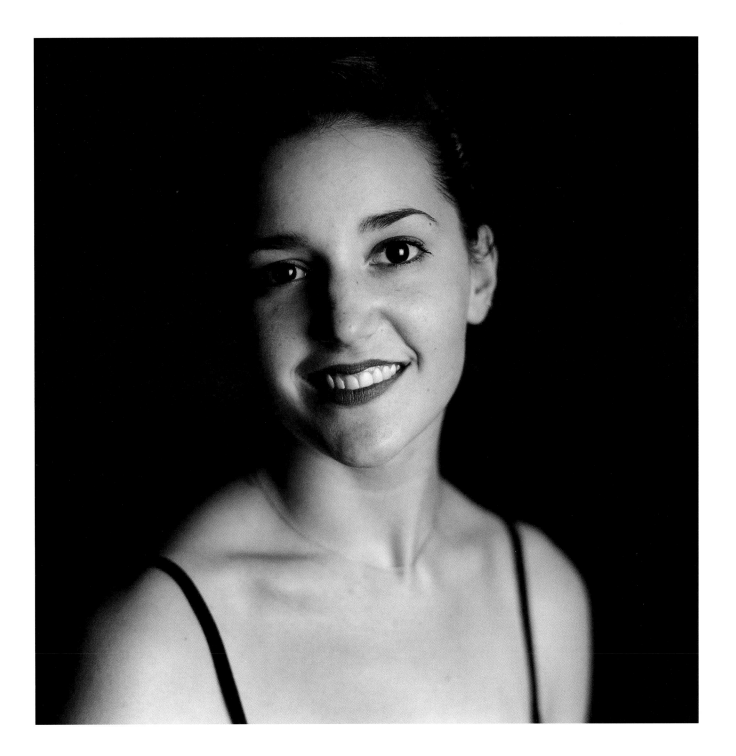

"When I get too old to rodeo I've still got grandkids and great-grandkids I can bore with my stories."

"GRANDMA JAN" YOUREN, 1943

TONYA JAN STEVENSON, 1960

TAVIA STEVENSON, 1983

TASHA STEVENSON, 1981

Grandma Jan Youren has grabbed life with all the gusto you'd expect from an inductee into the Cowgirl Hall of Fame. She's been married four times, reared eight rodeo-riding children, and won countless rodeo championships. Now well into her fifties, she still bucks at the idea of retiring.

JAN YOUREN

My dad is one of the old-school cowboys, and Mom was a city girl. She said we were responsible for every gray hair she had.

There are six of us in the family. I'm the second; I fell into being daddy's helper. Mom always tried to balance it out. She made my clothes. I had the prettiest shirts, I had some *fancy* fancy clothes.

I started rodeoing when I was twelve, and won probably more than my share of championships. I won the Girls' International Rodeo League in '67, and the world's championship for bareback rump riding in '81. In '87 I won with a broken back— I didn't know it was broke, I thought I was just being a pansy!

I broke my first bone when I was twenty-one. Since then I broke my nose eleven times, had eight breaks in my cheekbones, broke arms, fingers, legs, ribs. Last year I got scalped when a horse stepped on my head.

I was a lot more scared when my kids were riding than when I was. Tonya has had some pretty good injuries. But I'm pleased to see Tasha and Tavia rodeoing hard. I never did much practicing myself—Mom said Dad and I were hams, we just needed a crowd to be able to perform.

I have enjoyed myself absolutely to the fullest, I have milked every second for everything it was worth. I guess it's not right to be proud but I am definitely a proud mother and grandmother. When I get too old to rodeo I've still got grandkids and great-grandkids I can bore with my stories. If you can combine children with every-thing else that makes your life tick, you've had the blessings.

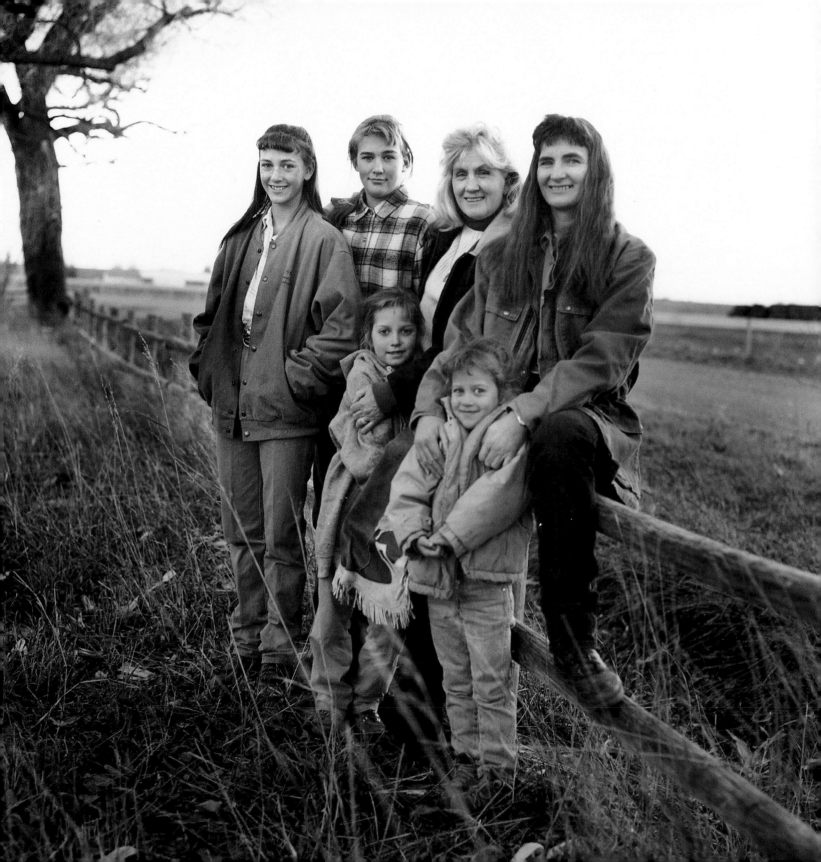

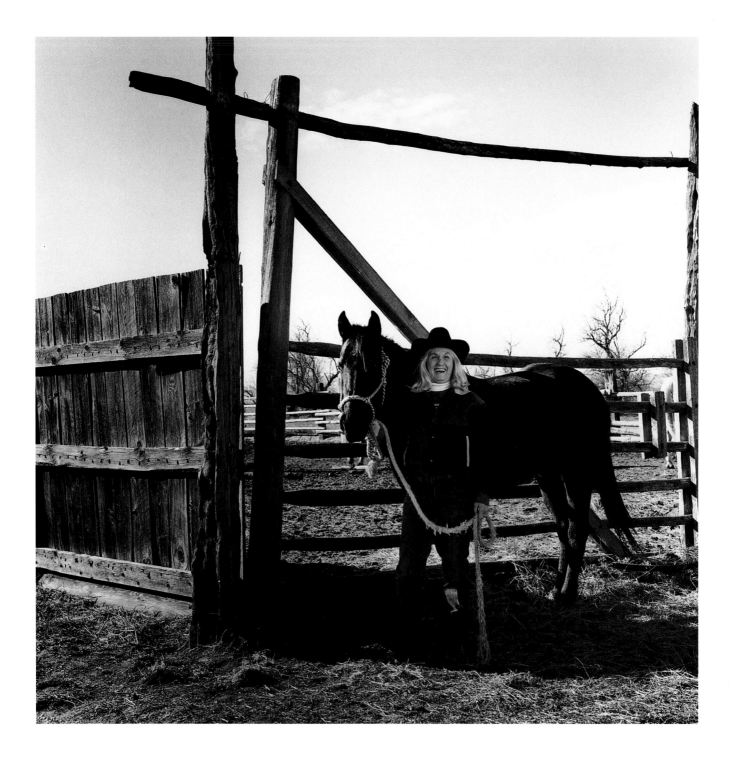

PAGE 49 *Back row, left to right:*
Tasha Stevenson, Tavia Stevenson,
Grandma Jan Youren,
Tonya Jan Stevenson;
bottom row: Tennie Stevenson,
Kaelea Stevenson

FACING PAGE
Grandma Jan Youren

TONYA JAN STEVENSON

I'm the eldest of eight children. Mom says I was her first and worst mistake. We grew up with rodeo. From the time we were just little we traveled continually.

Mom and I got to be good friends while rodeoing. But when I got married, Mom was riding bulls still and that's when rodeo started to bother me. I was sure I was going to watch her get killed. She would bruise her heart, smash her lungs, get stomped, and wouldn't go to the hospital. I remember my grandpa gettin' kicked and he said, "Didn't take a blankety-blank doctor to get this way and it won't take one to get better." Mom's just come that way. Honestly, I'd like to see her quit. But the more you ask her, the more determined she is to ride.

I quit riding bulls because my grandfather said he'd come to my wedding if I did. At that point I was burned out enough watching Mom get hurt that it was, "Okay. That's fine."

My husband led me to the Lord a year after we were married. He's a Baptist, I was raised a Mormon. We had a lot of fights, and finally I told him, "Okay, I'm going to accept the Lord, but I'll never be a stinkin' Baptist." Now I'm a Baptist.

I want my children to have what God's will is for their life. Tasha's really soft, she's such a tender heart. She would be one who would feel sorry for somebody and marry 'em. Tavia's quite the opposite. You see those dogs out there? She has dreams of Iditarod racing. She would grow a beard and be a mountain man tomorrow, if she could figure out how.

Everybody has their battles. I dislocated my hip, I poked holes in my lungs, and it hurt nothing near as bad as the emotional. By the time I was a senior in high school, life was something I didn't want. I had six world championships—so what? What good did it do?

Being a mother makes life worth living. I see myself in Tavi so much that it scares me. Tash, she's quiet but she knows what people are feeling. They're more spiritually mature than I ever was. They probably teach me more about unconditional love than I teach them.

My dream is for my mom to accept the Lord. She won't talk to me about it, but she'll let Tash do it. She's got a soft spot for her grandkids. It's almost like she's making up for what she missed—she buys gifts out the ears. The kids love her. They'll probably be the ones to win her.

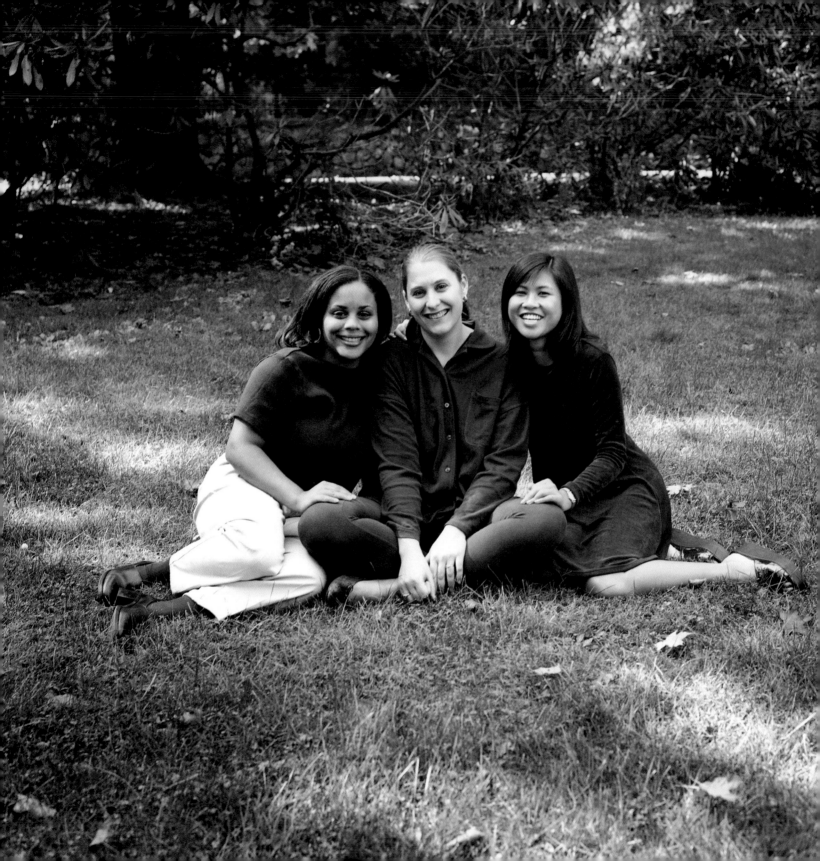

"We'd say, 'We're sisters,' and people would say, 'Oh, Big Sister program?'"

MARY ELIZABETH WATSON TAYLOR, 1908

ANN SWEENEY, 1931

MEGAN SWEENEY, 1965

FAITH SWEENEY, 1972

HOPE ANN SWEENEY, 1974

The big white house in Greenwich, Connecticut, looks much like others in the surrounding neighborhood. Its residents, however, do not. Here Ann Sweeney reared eighteen children, eleven of whom she adopted. One member of the multicultural tribe—daughter Megan—is raising a new generation of Sweeneys in the house where so many lives have taken shape.

MARY ELIZABETH WATSON TAYLOR

Ann was an only child, so being a mother for me is something quite different from what being a mother is to her. She's got all these kids and she's gotten one, two, three, four . . . I'd have to get pencil and paper to get it accurate, but the number that have gone and taken college—I think she's sent a lot of good children in a good direction.

ANN SWEENEY

Nobody in their right mind says, "I'm going to have eighteen children." I had three by a previous marriage, and I married again and had two children. Then I lost a baby. When I went to adopt for the first time, I was looking for a baby that needed me as much as I needed him. And Marcus was such a success that we wanted to adopt again; then I got pregnant. The twins were born slightly after eight months. And I was so thrilled that they both lived, I could have adopted an army.

So we adopted Faith and that made eight. Well, when you have that many children, you don't do anything else anyway. The ninth turned out to be the same age as Faith. So we had double twins. The next year we got Terry and we had four babies under two. Then we were contacted by a Vietnamese organization and took on a family of three.

Of the adopted kids, Marcus is of mixed race; Carey, Terry, and Michael are black; Faith is a black and white mix; Minh, Hope, Chuong, and Dat are Vietnamese; Maria is South American Indian; and Mike is white. There was a lot of cohesiveness among the children. God help the outsider who would attack, because suddenly you had a horde of Sweeneys—there were about nine of them in junior high at the same time. There was no racial problem. It's just a question of how close anybody wants to be with each other. I think the oldest three were the most uneasy with it; it's a

PAGE 52 *Left to right: Faith, Megan, and Hope Ann Sweeney*

little embarrassing when your mother is running around with a trail of multicolored children while you're trying to be a cool high school kid.

When my mother had lots of strength she used it prodigiously. She did laundry, she cooked. Now Pat, Tim, Hope, Faith, Megan, her children, and my mother all live here.

Nobody cooks. It's quite simple. When the kids were little, we used to have dinner together, but now I work and Pat goes to school and Tim's schedule changes, and if there's food we eat it.

I'm a private music teacher, and I also have a youth choir. During the day I teach handicapped adults. I am by definition a caretaker. That's one of the reasons I have so many children; this is where I'm happy with myself, where I get the most joy.

MEGAN SWEENEY

I'm the first of the second marriage, six or seventh in age, number four chronologically. I moved out when I graduated from college and lived on my own for almost ten years, but moved back because I wanted my kids in a neighborhood where I didn't have to worry that their bikes were going to be stolen. It worked out because I run a domestic violence shelter—I work crazy hours—and it was good to have other people in the house. It's about all I can put on my plate, being a single mother and raising two kids.

Growing up here in Greenwich, people have very definite molds. When we were younger and we'd go places, Faith, Hope, and I, we'd say, "We're sisters," and people would say, "Oh, Big Sister program?"

It's funny because there are six girls and twelve boys and we just totally bowl over the boys. A lot of people would call us a bunch of domineering women. But I think that's a good quality.

FAITH SWEENEY

Coming from a family like ours, you really had to work for everything you wanted. Survival kit!

It was fun having a lot of playmates. As we got older I would say there was sibling rivalry, and now we're trying to work out dealing with each other as adults.

I think I would adopt, but not as many as she did. There are children out there who need to be adopted, and hearing these horror stories—some of my brothers

came from foster homes and the stories weren't so great. I know that I would be able to offer somebody a good home when I'm on my own.

I love my mom. Anybody can have money, but if you don't have that love, then I don't think I'd be where I am.

HOPE ANN SWEENEY

Growing up here was always pretty fast-paced—basically just like any other family with four times as many people, four times as many problems, four times as many positive sides as well. On our family vacations we outnumbered the parents, so it was so much more fun.

I really feel molded by the Sweeney family. My grandmother was an English teacher and she taught me how to speak correctly, and that there's a right way to do things and a wrong way.

I saw my biological mother a couple of times in California. She's traditional Vietnamese. I know something about her history and that she had a turbulent past. But I don't know her language, I don't know her culture. I have two brothers who are living out there now. Chuong was adopted when he was a lot older, so I think he had more memories of the other family and felt more attached.

I really like the fact that we are still living here. The family has gone through a lot and we stay together. My mom's great. She's kind of crazy, in a good way— she's done everything to the extreme.

Back row, left to right: Hope Ann Sweeney, Faith Sweeney; front row: Megan Sweeney, holding Devon Bedoya, Ann Sweeney, Mary Elizabeth Watson Taylor

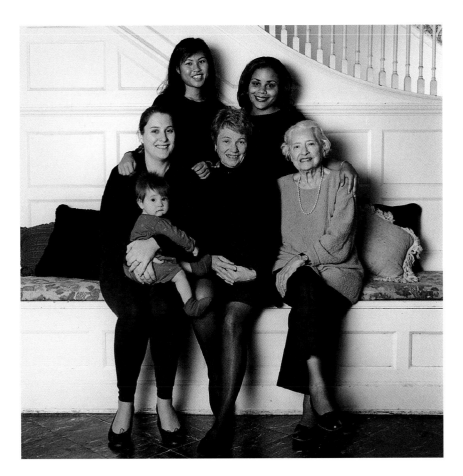

"When you've got children, you can't tell them, you just have to let them get a pattern after you."

LAURA MORROW, 1907

EVELYN SHEPARD, 1924

PEGGY MORROW SHEPARD, 1946

NICOLE ELISE JACKSON, 1965

From the time she was a little girl, Peggy Shepard has understood that volunteerism is a natural and necessary part of life. Although the shifting shapes of relationships, geography, and fate have taken their toll on the Shepard clan over the years, Peggy, her daughter, Nicole, her mother, Evelyn, and her grandmother Laura have remained true to the belief that no woman is an island—each is a part of her family and her community.

LAURA MORROW

I got married young—at fifteen—and had five children. I think that as a mother I should live in a way that I want my daughter to live. Because when you've got children, you can't tell them, you just have to let them get a pattern after you.

Oh, my, if I could tell you all the dreams that I dreamed for Evelyn! I wanted her to be a teacher. Then I'd turn around and say, well, if she can't be a teacher, let her be an asset to the generation that comes.

I don't have any regrets at all. At this age I should be happy! That's one thing I said I hope I would live to see—my grandkids grow up and then have great-grandkids.

EVELYN SHEPARD

Peggy was a dreamer. I was a dreamer. My mother was a dreamer. I always felt that I could live in Buckingham Palace, and Peggy did the same thing. She knew what she wanted to do and how she wanted to do it.

I was twenty-two when I got married. I started out as a music major, then changed to education. I started working and then I had children and that was it. My first two children, Peggy and Nina, six years apart, I had no problems. But when the mod squad came along, Shelley and her twin brothers . . .

What I tried to do with my children was to set an example. They should know what was right and what was wrong, and I didn't have to preach it every day. Whether or not they followed it, it was up to them.

I had six children and I'm very happy and proud of them. Sometimes you wish that you could have done more, but time passes, that was yesterday. I'm still learning, even at my age. Especially human nature!

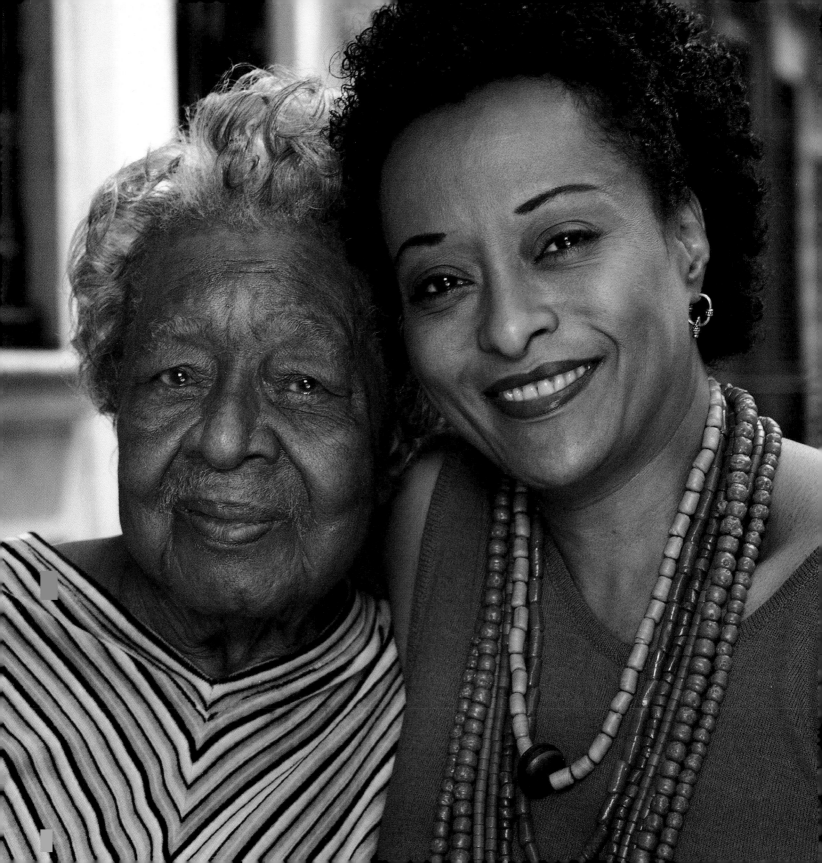

PEGGY MORROW SHEPARD

My father was the only black obstetrician in the city of Trenton. He delivered practically every black baby in town. He had to deal with girls and boyfriends and premature pregnancies; the dinner table conversation was always around women in crisis.

In a small town, everybody knows you. We had a great house, and a swimming pool. I had a beautiful mother who had a beautiful white Imperial. You know women in the fifties, how they dressed—I looked up to her as a movie star. It was a pleasure when she'd take me to one of her fund-raising luncheons. My mother never said, "Volunteering is good." I just saw that she did it and even my father, who was the busiest man I knew, did it.

PAGE 57 *Laura Morrow (left), Peggy Morrow Shepard*

BELOW *Left to right: Nicole Elise Jackson, Laura Morrow, Evelyn Shepard, Peggy Morrow Shepard*

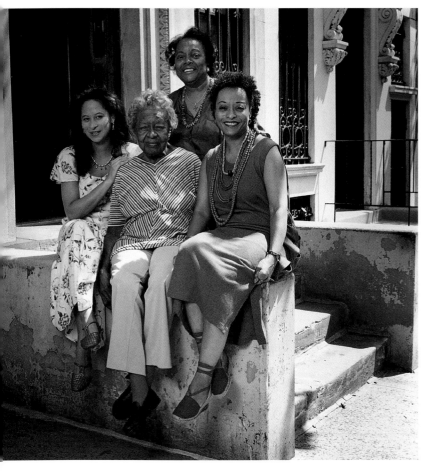

I was born with disfigured hands, so I couldn't play instruments, but I took ballet, and ice skating lessons. I went to Howard University in 1963. I was sixteen and I'd never had a boyfriend, so a senior totally enveloped me and in a year I got married. We went to Indianapolis and I was very bored and depressed. Then someone told me about an opening at the *Indianapolis News*. I don't know why it's making me cry to think about it . . . I just walked in and got the job.

It really started my whole professional life, and it also made me want to pursue my career in New York. And in doing that I basically broke up the family.

In New York I could do what I wanted, nobody would be watching me. I was anonymous. Then I ran for office! I represented West Harlem as a Democratic District Leader from 1985 to 1993; in 1988 I cofounded WE ACT, which works to clean up the environment in urban neighborhoods.

Nicole was an adorable daughter, smart. She went to the U.N. School; math and science were her best subjects. And that was her father's influence, you know, him being an engineer. She'd spend vacations there, and then there was a point when custody was reversed and she was with me on the holidays.

It was really hard. She didn't have the concentration of time with me that I did with my mother. I think every child probably goes through some kind of problems when there's a divorce, and I think you always kind of second guess—"Suppose I hadn't done this." So it makes you really come to grips with, "I've done a, b, and c, and yeah, it was really selfish."

There are all kinds of things you can imagine you might have wanted to do. But in terms of what I set out to do, I sort of got there. If you have an idea, you can make it happen.

NICOLE ELISE JACKSON

I lived with my mom until I was eight. When I went to live with my father, I don't recall feeling that torn. I was very happy in California. When I lived in New York, the bus dropped me off, and by the time anybody came home it was dark. In California there was a swimming pool and lots of kids. You know, I didn't have to take cabs to their houses.

My father and I are very close. My mother and I are close in a different way. I think we're fundamentally different. I might have been going to calculus class while she was trying to make me a debutante or something, you know?

My mother's father went to Howard and so did my father's father and my parents. I went to Stanford. As far as my accomplishments go, the first thing I think of is graduating. But I would hope that I would have accomplishments that help mankind, or at least a person or two.

I did tutor high school students in trigonometry and geometry. It seemed like if I could help a few girls get through geometry, maybe they'd go on to Algebra II and actually get into a decent college. And I used to be a Girl Scout troop leader, does that count? I probably got that from my mother, because my father certainly doesn't do that sort of thing.

My mother is so beautiful and she's always together. She can speak in front of groups of people, and no matter how angry she gets she can always present herself well. I sometimes wish I had that. I have a tendency to wear my emotions all over my sleeves and clothing.

I do have the utmost respect for her. I remember articles in magazines and showing them to my friends; when she was running for office I put her flyers up. I love her very much and I would imagine that as both of us mature a bit, it will get even better.

"*I guess I believe that everyone deserves a second chance.*"

EVELYN M. SHENKER,
1905

MARJORIE BROUS, 1936

SUZEN PETTIT-D'ANDREA,
1957

ALEXANDRA KATE PETTIT,
1987

Marjorie Brous was an only child whose parents split up when she was three years old. Marj had one daughter, Suzen, and divorced when Suzen was four. Suzen's daughter Alexandra was also four when her parents' marriage fell apart. But Suzen believes in new beginnings. On the day of her second wedding, she was photographed with the women in her life. Since then she has given birth to Rebecca Grace D'Andrea, who, like little Alex before her, promises to further heal a family scarred by estrangement.

EVELYN M. SHENKER

My life with Marj was wonderful. She was my breath, my laughter, and my tears. When people saw me walking down the street without her, they'd say, "Where is your shadow?" I was the envy of a big apartment house.

When Marj got married and had Suzen, my God, I was there to relieve her every day. Then my second husband died. Suzen was quite small, so we went to Texas because Marj and her second husband had a little business there. By that time Marj had her second baby, and I really took a great deal of care of Suzen.

Marj and Suzen are very close, and Suzen's relationship with her daughter is the greatest. They're like two kids together. That little one, my God, I mean, Alexandra can play the trumpet, do her homework, and bake cookies. . . . I don't know how she does it!

MARJORIE BROUS

Mother was separated when I was three years old. My father was a playboy, and Mother confided in me from the time that I started to walk. When I was Alex's age I was saying, "Look, you married a guy who was not a family man and so you can't expect more from him."

My mother forced me to make decisions for her. I used to lay out her jewelry, her pocketbooks, everything, before she went out. She was a perfectionist. Now mind you, we had no money. There were times when we had to cash soda bottles. Where she got the clothing I don't know, because she claimed that my father left her penniless.

I lived with my mother until I met my first husband, then we moved close by. She never helped me; she was always extremely self-involved. I didn't want Suzy to be as materialistic as my mother, and I fought it.

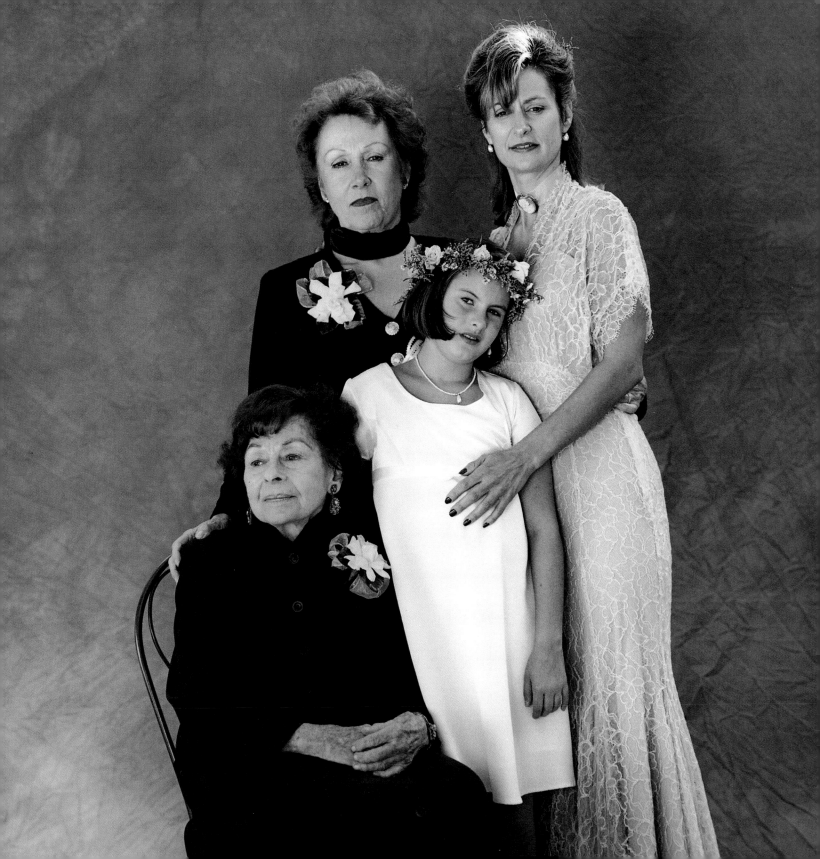

For Suzen's sake, I do regret the breaking up of my first marriage. I'm not particularly comfortable with myself, and I work on myself all the time. I guess I've protected myself against feelings. But when Suzy told me she was pregnant, I was really blown away. I was just overwhelmed that my child was having a baby.

I hope Alex is Xena the Warrior Princess. I hope that she has a wonderful career. I think marriage is fine, but what prepares a person for marriage? I really can't tell you what the formula is.

SUZEN PETTIT-D'ANDREA

I grew up with my mom until I was seven. It was very confusing. We lived in Long Island until I was four, then she took me and my grandmother to Texas. She remarried there, and my brother was born there. My father never knew where we were—he had the FBI looking for us. The man that she married was from Long Island also. He had a whole family of his own that he left behind. Four kids.

After about eight months I came back with my grandmother. Eventually my mother, her new husband, and my baby half-brother came to Connecticut, and I moved in with them.

There was so much anger between my father and my mother.

Then my father met a woman, Frankie, and they got married. They really wanted to get me out of my mother's house, to the point where they paid for me to go to summer camp for eight weeks. There was a bad scene when Frankie came to take me to camp. I remember phone lines being yanked out of the wall; when Frankie and I got in her convertible, my mother's husband got in his truck and bashed us down the driveway and across the street. We could have been killed.

That summer Frankie and my father asked me if I wanted to come live with them. What was I going to say? I was seven, and petrified of my mother's husband. I didn't set foot in my mother's house again until I was sixteen or seventeen.

Frankie was so young—twenty-one years old. I really saw her as a savior, as the

ABOVE *Marjorie Brous embracing Evelyn Shenker*

PAGE 61 *Clockwise from top right: Suzen Pettit-D'Andrea, Alexandra Kate Pettit, Evelyn M. Shenker, Marjorie Brous*

Suzen Pettit-D'Andrea embracing Alexandra Kate Pettit

person who came and said, "This isn't okay." She had no background with kids and yet I think she really loved me.

My mom became more of a friend. When I went to graduate school, I moved to Connecticut to be near her. It was the first time I'd lived close to her since I was a kid.

Then I met Russell. And did I know when I was walking down the aisle that I was making a huge mistake? Yes. I wanted to make a life, and he wanted to sit in front of the TV and drink beers. Then we had a baby. When I got pregnant, I thought I was going to raise her with all the love that a child can be raised. Never in my wildest dreams did I imagine getting a divorce.

But Alex has been the glue that's brought the rest of us together. From the day she was born my mother's husband has been a wonderful grandfather. I think both he and my mother had so much guilt over the past that they have really thrown themselves into it. God bless 'em, you know? There's so much love that my mother always wanted to give; she was just stuck for so many years that she couldn't.

I guess I believe that everyone deserves a second chance. God knows in our family we've all been given our fair opportunities to screw up and then get our acts together.

I was very happy as a single parent. Then I met Michael and we just clicked in every possible way. He was like coming home for me. Now I'm forty and I'm having a baby, can you believe it? It's been the best year of my life.

ALEXANDRA KATE PETTIT

Mom and I lived alone for a while and it was kind of cool because we always got to have a girls' night out. If I had a bad dream or something I could sleep with her.

I think I'll get married once. I think I'll have kids; I hated being an only child. Now I'm going to have a baby sister. I would like us to have at least the same last name. My mom has two, I have one, Michael has one but it's different from my mom's. The baby's is going to be different from mine. But I'm happy because my mom and dad are good to me and I have Michael.

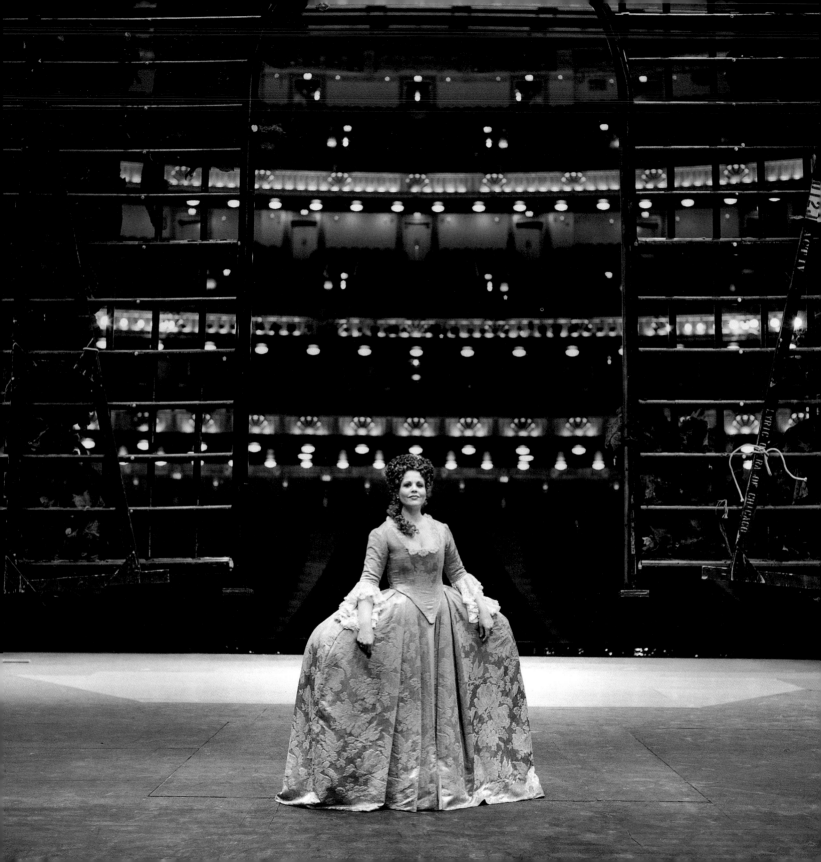

"I sang opening night at the Met when my second child was one month old."

PATRICIA ANN SEYMOUR ALEXANDER
RENEE LYNN FLEMING, 1959

Patricia Alexander wanted her daughter, Renée Fleming, to be a singing star. But it wasn't until Renée set out on her own that she found her true voice. And it wasn't until Patricia had a son late in life that Renée realized she wanted to have children. Now Renée is a renowned soprano and takes her children on tour all over the world. She is so protective of their privacy that she will not have them photographed or identified by name.

RENEE LYNN FLEMING

My mother is extremely talented, and when she got married and had us, I think she transferred her wish for success on the stage. We took piano lessons and dancing lessons; I did a lot of musicals and she was there, making the costumes, really pushing us in that direction.

I was a rather shy kid. My nickname was Stoneface because I would sing in these choral events and there was no enthusiasm—I wasn't going to show anything. I was so conflicted because I really didn't enjoy performing—it was something I *had* to do.

I was in my twenties when I moved to New York, and then I had a Fulbright grant. I studied in Germany and I really found my wings and that, I think, was very threatening to my mother. We went through a rough couple of years. There was a lot of frustration on her side—this was when she was divorcing my father. Then she remarried and had a baby, her fourth child. She changed a lot during that period. She now teaches at Eastman School of Music and she does a fantastic job. You know, she really didn't need me anymore as an extension of her, and it was at that point that I had my children, too. Now we're very close and she is devoted to my children, which I really appreciate. It's so great to have that.

I was at my half-brother's birth. I was twenty-three. It was pretty incredible. I was holding my mother's hand, and it was at that moment that I realized I wanted to have children.

I talked to a lot of famous sopranos—people who have done everything, who are incredibly successful—and they all said having children was the best thing they ever did. So I never questioned it. I sang opening night at the Met when my second child was a month old.

PAGE 64 *Renée Lynn Fleming on stage at the Lyric Opera of Chicago*

My daughters are on the road with me. Every city I sing in I have to find an apartment for six weeks or two months, and this year I have to find schools in every place. The amount of sheer organization. . . I sing at least sixty performances a year. I'm constantly learning a new repertoire and having meetings and making records. I don't even know how I do it. But I don't look at it as something difficult; it's made me incredibly happy. These girls are with me. My colleagues are on the road in hotels by themselves and I have it all, a totally rich life.

PATRICIA ANN SEYMOUR ALEXANDER

I have a son who's thirty-three, a daughter who's twenty-eight, and my youngest son, Geordie, who has just turned fifteen. And, of course, Renée. She saw Geordie before I did.

My mother sang and played and was a church organist, and I sort of followed along in her footsteps. I was the first child in my family to go to college. I would have rather gone to Hollywood because I had these great ideas that I was going to become an actress or a movie star. And I ended up in school. My mother had very high expectations, you know; she still criticizes me when I sing.

I guess I was just like my mother. I wanted Renée to be a performer, which is the thing that I had really wanted to do. She didn't resist; I remember telling my friends, "I don't know how I ever did her," because she was quiet, she was shy. I mean, she was what you'd think of as a perfect child. When she was an infant we took her in a little Moses basket to choir practice. When I was teaching privately, she'd be sitting there, she was just an angel.

Renée always had a calming effect on me. I can remember her telling her father, when I was having a little tantrum about something, "Daddy, don't worry. She'll be all right." If I believed in reincarnation, I don't know—she was an extension of myself, the best of me. She didn't have the qualities that I didn't like in myself. When people say she's beautiful I always say, "Yes, but she's just as beautiful on the inside."

FACING PAGE *Patricia Ann Seymour Alexander (left), Renée Lynn Fleming*

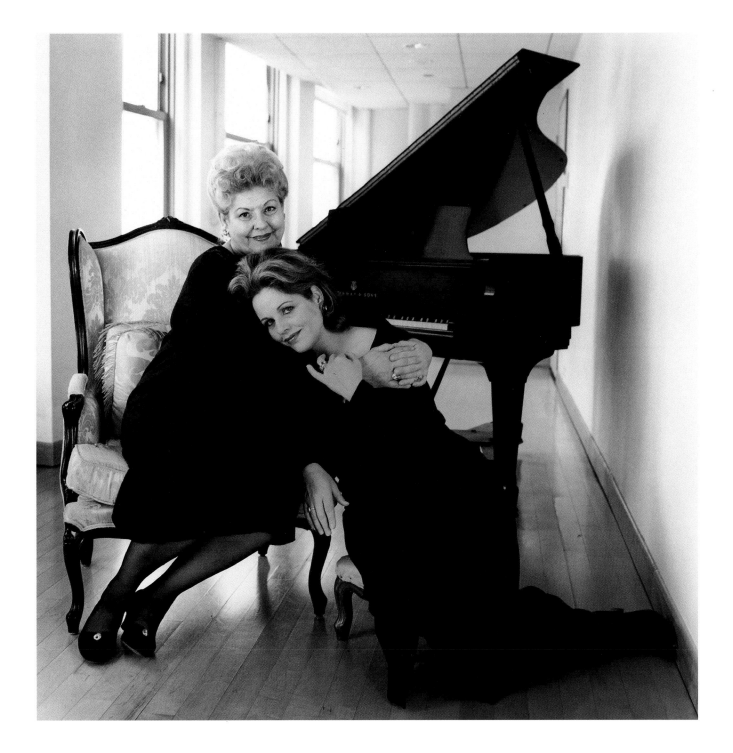

"Quite literally, mine was a voice unheard."

BIVA DAS, 1920

SHAMITA DAS DASGUPTA, 1949

SAYANTANI DASGUPTA, 1970

Shamita Das Dasgupta was sixteen when she became a wife. It was an arranged marriage, and at first an unhappy one. Though she ultimately found joy as a scholar, activist, wife, and mother, she was haunted by her mother's decision to "marry her off" at such a young age. On a recent trip to India, Shamita interviewed and photographed her mother, Biva Das.

SHAMITA DAS DASGUPTA

I started school in the sixth grade and graduated at sixteen, the same year I got married, during a Communist revolution in Calcutta. There was high unemployment, people were starving. I was very much influenced by what was happening around me, the political issues. I had decided that I'd never get married, I'd work in a system where I would be able to affect people's lives. But I didn't have options. It was not possible.

My husband wanted to marry me. His parents and my parents decided, "This is the best thing." It was arranged. My mother was trying to do the best she could; she thought that being nontraditional would hurt me. Yes, I should be educated, but my first duty is taking care of my family.

Quite literally, mine was a voice unheard. I was very angry, and my anger manifested itself by my having a terrible relationship with my husband. He decided to come here in 1967. There was nothing else that I could do.

When I came to this country—I was in Ohio—I went back to school. The women's movement was a big thing, and I started participating vigorously in women's collectives. But they did not think that racism was an important issue. That's when I started realizing that I was an immigrant in a country where immigrants are seen as weird. I was a woman who came from a heritage that people didn't understand. I left the mainstream women's movement in 1985 and cofounded the first South Asian women's group in this country, Manavi. We ended up focusing on domestic violence. Now I'm an assistant professor at Rutgers University—psychology and women's studies.

At every step my husband and I would have fights, and I would end up saying, "Well, if you can't do this I'm leaving." And interestingly, he would learn, he would talk to people or get books and read. He's ended up being quite an activist. We are friends now, the closest.

68

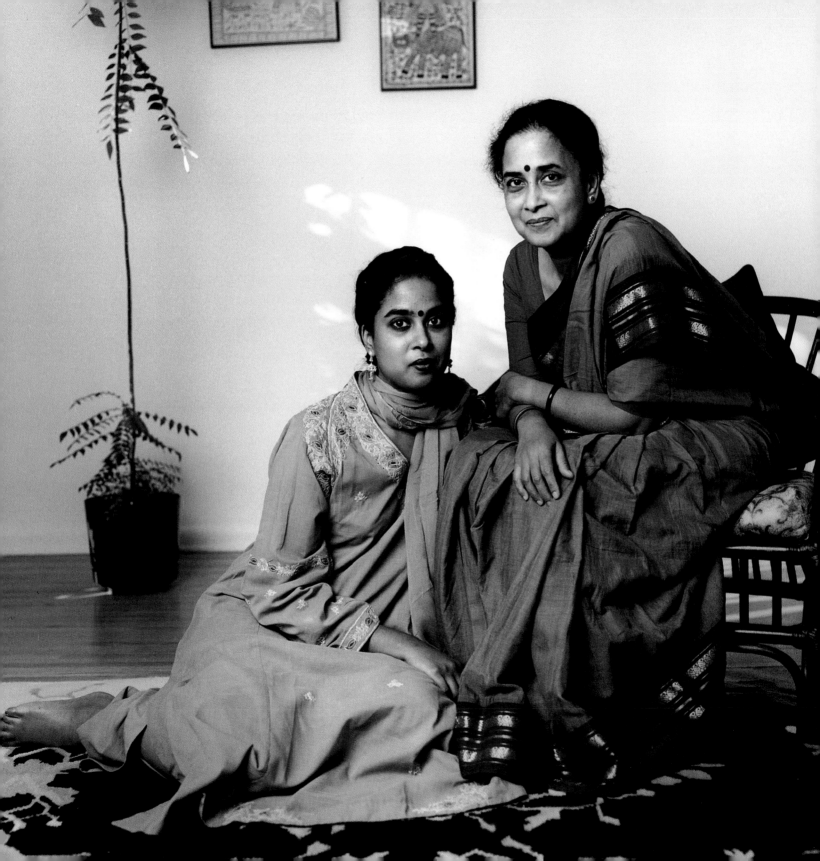

PAGE 69 *Sayantani DasGupta (left), Shamita Das Dasgupta*

My tremendous interest has been in power relationships, how power seems to divide us as human beings. When women walk around the house and are afraid, that's abuse. My mother was very dominated by my father. She should have left him long ago.

I don't want my daughter to be comfortable with the way things are. But all you can do is provide your child with information and hope that it works. From about fourteen to seventeen she wanted to be Mrs. Brady or something! And then I saw her getting involved in Third World movements, and she went to medical school thinking about women's health as an activist issue. Something seeped in there!

She speaks fluent Bengali. She went back to India almost every year. It's very important to me, passing things on to the next generation. I want my daughter to bring up children, not just biological children, anybody to whom she can pass on all of this fire.

BIVA DAS

My mother loved me. When she read the *Gita,* I would sit near her. She wrote poetry. Once in Chittagong there was a meeting of Gandhi and Netaji [Subhas Chandra Bose], and my mother read a poem of her own.

There were four sisters and five brothers. She wouldn't let us work in the kitchen. She would say, "No, go study." But as soon as I passed my matric exam she died. Father would also say, "Go study," but he didn't like the girls to leave the house; the school collected my sisters from the back gate so he didn't see them go.

My sisters were married off early, at thirteen and fourteen. When I was thirteen my elder brothers

Biva Das

sent me to school. All my studying is for them.

My marriage was arranged. I was studying for my B.A. but had to quit because Chittagong had been bombed. By then I was quite old, twenty-five or twenty-six. My brothers were careful they wouldn't marry me to someone without a degree. So I got arranged, I got married, that's it.

I did cry; there were times I thought I couldn't stand it. But I did stand it. For the last twenty years we've lived separately—my husband lives downstairs and I upstairs.

I married my daughter off very early, but it was to a good boy. My daughter didn't want to get married, but she wasn't so strong-willed or vocal about it. She just said once, "Ma, you're marrying me so young, and you're not letting me study?" Now she has made her happiness for herself.

She has a daughter who has just become a doctor. My granddaughter has done as her heart desired; she didn't stop to think, "What will this person say?" and this is best. For this I am happy.

From my daughter I have learned independence. Women should care for all, love all. This responsibility I can't let go of, it's my second nature. But why should you stand for bad treatment? You make yourself strong. Now that I am older, I can stand.

SAYANTANI DASGUPTA

I'm an only child and my parents were immigrants, so I was kind of the "little brown girl in the heart of the Midwest," and that definitely impacted my growing up. On the one hand, the Midwest is a safe and kind of neutral place. On the other hand, there's so much battering of, you know, a small brown person's self-esteem.

I didn't think that my parents recognized what it felt like to be a minority child growing up in a majority community. There was a world outside that I could function in, but there was a world inside my front door where a different language was spoken, different clothing was worn, and I would feel very uncomfortable when outside and inside collided.

The fun side is that my mom was a student all through my childhood. I sat through her classes, I was constantly with her. You know, our politics grew alongside each other. We went to rallies, I watched her form Manavi. Community work was always there and that's why I went into medicine—I saw it as a really concrete and powerful tool for social change. This is my milk and cereal—politics was at the breakfast table.

The kind of contradictory thing is that my grandmother didn't want me to get married when I was young. There's this notion of the physician being a helper of the poor, and so my grandmother was like, "You need to not be bound down by a traditional role."

My fiancé's parents speak German, my parents speak Bengali, so my kid will have to learn three languages. I'm looking forward to it because I had so much fun with my mother. I think it's the most important thing I'll ever do.

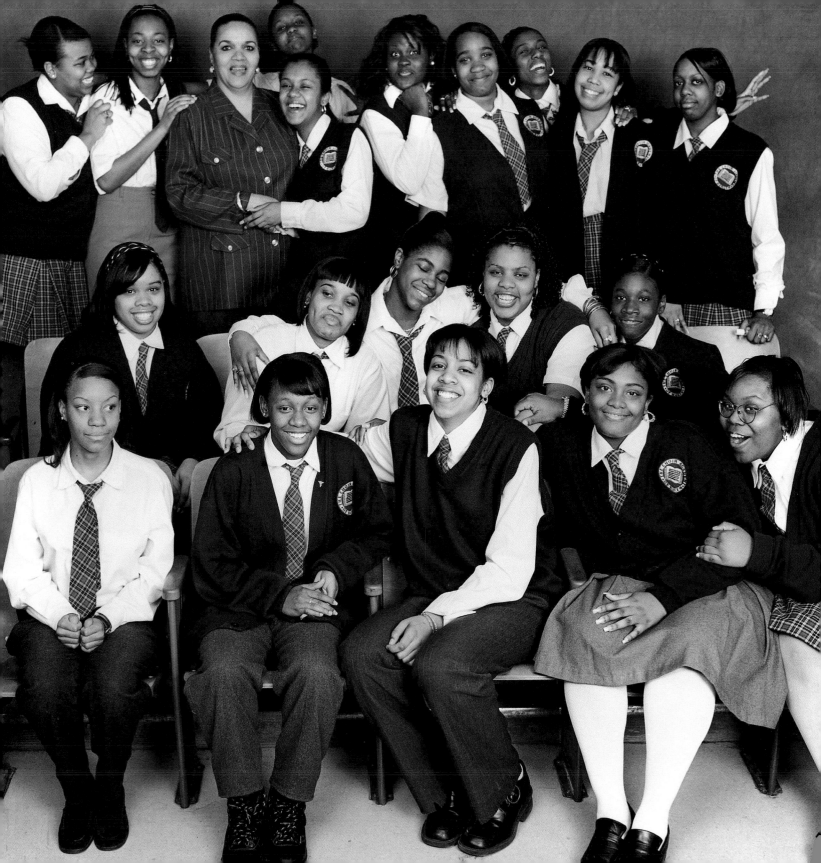

"This school is extraordinary.... Everyone that comes here has a good chance of becoming something in life."

MARY R. WHARTON, 1937

BARBARA ANN MORRISON, 1956

COSINA NASHEA MORRISON, 1980

The Choir Academy of Harlem is a public school whose five hundred students are tutored and groomed to perform in either the Boys Choir of Harlem or the lesser-known Girls Choir of Harlem. Many of the choir members come from compromised households; others, like Cosina Morrison, come from a long line of powerful, positive women who make the most of what they've got.

MARY R. WHARTON

My mom was perfect to me. She raised us with respect, so that's how I brought my kids up. She's been dead now around thirty years, but I had eight kids when she passed. I almost had 'em all by twenty-eight. Every year I had one!

Barbara—I call her Bobbie—well, she was the first born. So she was like a mother to all the rest because I worked every day. She was my friend. Everywhere we went they would say, "Ooh, are you all sisters?" She would tell 'em, "Yes!" Now I miss her so much, but she comes home every chance that she can. And I spend time with Cosina every summer. When she was on TV we were just so proud of her, and her grandaddy was so excited.

I have about seventeen grandchildren. I sit back and look—how did I do this? It was hard at first when I was having all these kids young. I had to get out there and raise 'em. I didn't want to put 'em in a foster home. So that was the hardest thing, but I made it. I had more than I wanted, but I'm so glad. They got me spoiled.

BARBARA ANN MORRISON

Growing up, there were rough times and there were easy times, but being the oldest, I had seven others under me to take care of, so sometimes it got pretty hard. At the age of five I was left with two younger brothers. I think at seven I fried my first egg. I would watch my mom—she taught me how to do it.

When I got out of high school, I joined the Army. Then I met my husband and started a family and picked up college later on. My first child was born in South Carolina, then we moved to New York. Cosina and my son were born there.

I went into social work, child development. I grew up with it, and it just stuck in me to take care of kids. Now mostly I'm in the field, going into homes to make sure that kids are provided for.

PAGE 72 *Some members of the Girls Choir of Harlem. Front row, third from left: Cosina Morrison; back row, third from left: Lorna Myers, director of the choir.*

FACING PAGE *Clockwise from top: Barbara Ann Morrison, Mary R.Wharton, Cosina Nashea Morrison*

Cosina studied music all through elementary. She loved to sing—she would go on and on. It started from when she was two. When she was in the eighth grade, her teacher recommended that she audition at the Choir Academy of Harlem, and she's been at it ever since.

It has changed her life. She's learned so many things—it's a positive atmosphere. Now she's gotten a scholarship at Fisk University in Nashville, so she'll be right close to her grandmother.

You know I have my sister's kids. They're ten, seven, four, and two. Taking them in was a hard decision for me after raising mine and wanting to put my feet up for a while. So Cosina has her little nieces and nephews, and I train her to cook for them and help them with their homework the same way I had to do. And she enjoys it.

COSINA NASHEA MORRISON

I love my mother. She's like my best friend. And she gives me responsibilities that make me take on womanhood, you know? I think when I get out in the real world, I will be prepared.

I get up at about 5:30. I help dress the kids, make sure their homework is done, feed them sometimes. It takes me an hour to get to Harlem. I stay in school twelve or thirteen hours. It's hard, but the work pays off. It's not like a regular high school. The school is extraordinary. There are no drugs, no metal detectors. Everyone that comes there, they have a good chance of becoming something in life.

My teachers ask me, where do I see myself ten years from now? I want to be the head of my own studio, a producer. I'm going to college for music engineering and technology, and I cannot wait. I'm going to miss my mom, but I'm happy that I'm going.

I think that I'm very joyous. I have life spirit, so when my mom is down, I'll say something to prop her up, you know? And she'll start laughing and we start talking. I'm so proud of her. She is such a good influence on me and I love her so much! I don't think that I can live without my mother or my grandmother. They're like the cream of the crop.

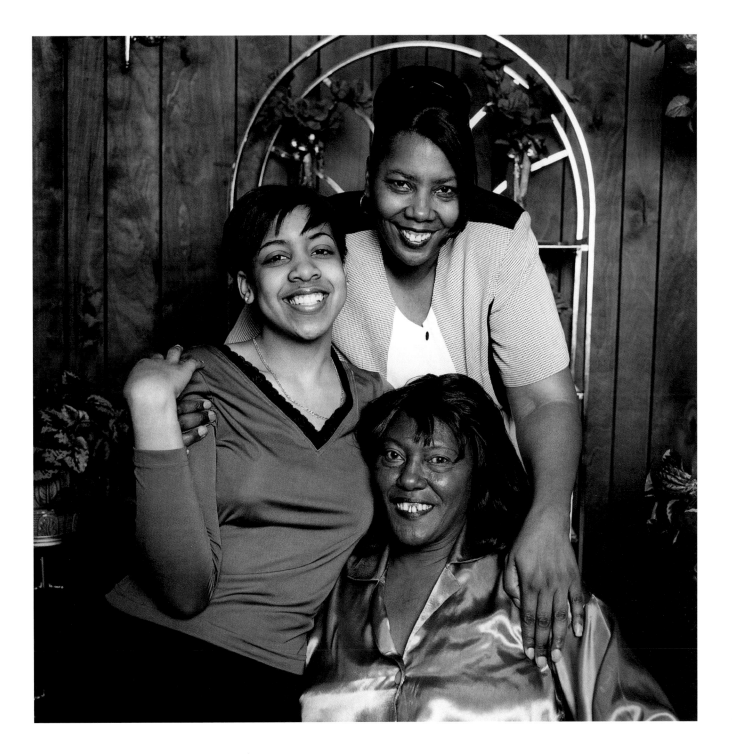

"As soon as I felt the pain I would feel better, you know?"

LAVERNE BOTTANDO,
1929

NANCY McARDLE, 1953

JILL McARDLE, 1980

At the age of sixteen, Jill McArdle revealed a terrible secret: for years she had been clandestinely cutting and burning herself as a way to relieve anxiety. With the support of her family, including her mother, Nancy, and her grandmother Laverne, Jill came forward and shared her story with a national audience. She also shed light on SAFE (Self-Abuse Finally Ends), the program that helped turn her life around.

JILL McARDLE

When I was little my older brother was really sick, he was always having surgery, so I tried to make life easier for my mom and dad. I just held everything inside and tried to be perfect. Like, I potty trained myself, and if I fell down I would never cry. When I was in grammar school it was easy—I went to school with maybe fifty kids. But then when you get into high school it gets a lot harder to be perfect. I go to the largest all-girl private school in the country; you have the athletes, the scholars, and like, where do I fit in? I just felt that I wasn't measuring up. If I didn't get all A's I was worthless; everyone had to like me or I was devastated.

I think the first time I ever cut my leg, my mom was mad at me for—I don't even remember for what. But she got mad at me, and I was like, I'm causing her so much pain, you know, I gotta cause pain to myself. And I would go into sort of a rage, like some other person in another state of mind, and then I would just start cutting myself, and it was kind of a release. As soon as I felt the pain I would feel better, you know?

My mom knew that I wasn't happy, and I felt bad for her. I was just like, I'm going crazy here. If I could just tell her, it would save so much grief. But I never looked to her before for any sort of—I don't know, it was like I had to take care of her. It was weird.

I'd been doing it for maybe five months, and my friends would see a cut on my leg and it was like, "Oh, I fell into a bush." Then they'd see another one and another one, and I got to a point where I carved "Life Sucks" into my leg with a protractor. So they told my parents, and I went into the hospital. But they thought I was just depressed, so my parents still didn't know about the cutting. They didn't know about it for like, three years.

I finally got scared before I went into the hospital this last time because it wasn't helping me. I was sitting there with a piece of glass, cutting at my wrists, and I'm like, "Why isn't this working any more?" And then I took an aspirin overdose. I didn't want to die, I wanted somebody to be like, "This girl's in trouble," you know? I woke up in the middle of the night and I was puking all over the place and hallucinating. Finally I told my mom. I was just like so out of it, and she finally realized and called my dad. He's a cop; he met us at the hospital, and I was in intensive care, and they kept giving me blood tests—I must have had thirty a day. So the doctor noticed when they were taking blood that I would be smiling, and they put two and two together.

I was an in-patient at Rock Creek, where the Self-Abuse Finally Ends (SAFE) program is, for like three weeks. My mom came every day. So did my dad, except maybe once or twice when he had to work. Every time my mom came, she would bring a card from my grandmother, or flowers or teddy bears, and it really meant a lot.

Sometimes I still get mad at my mom and don't talk to her. But, other than that, she pretty much knows all. We're definitely friends. She wants me to make myself happy, and if I'm happy I'll be who I am and that's enough. Me and my mom and my grandma are like, I don't know, like sisters, but different.

I guess you've just got to trust other people that love you. I think a lot of it has to do with letting them help you, not trying to grow up too fast, and being able to forgive people. I needed to forgive myself, 'cause you know I felt like I'd caused so many problems.

I'm a senior now. School's been good. Last year I would have given anything to stay home. But this year, I don't know, I like my classes, I like my teachers.

I still want to make people aware. When I was on *Geraldo,* some girl e-mailed me and said, "That gave me the courage to tell someone." On the Internet there's a message board for people that self-mutilate, and there's all this e-mail, like, "Thank you, you changed my life." I remember how it was to feel that way, and someone could have come on TV and I would have been like, "Are you kidding? I'm not the only person in this entire world that's doing this thing?"

They say that it's never—it's like being an alcoholic, like, you'll never be completely rid of it, you just have to keep battling it. But this part of it's over for me, anyway, as far as I can tell you right now. I have to knock on some wood, here.

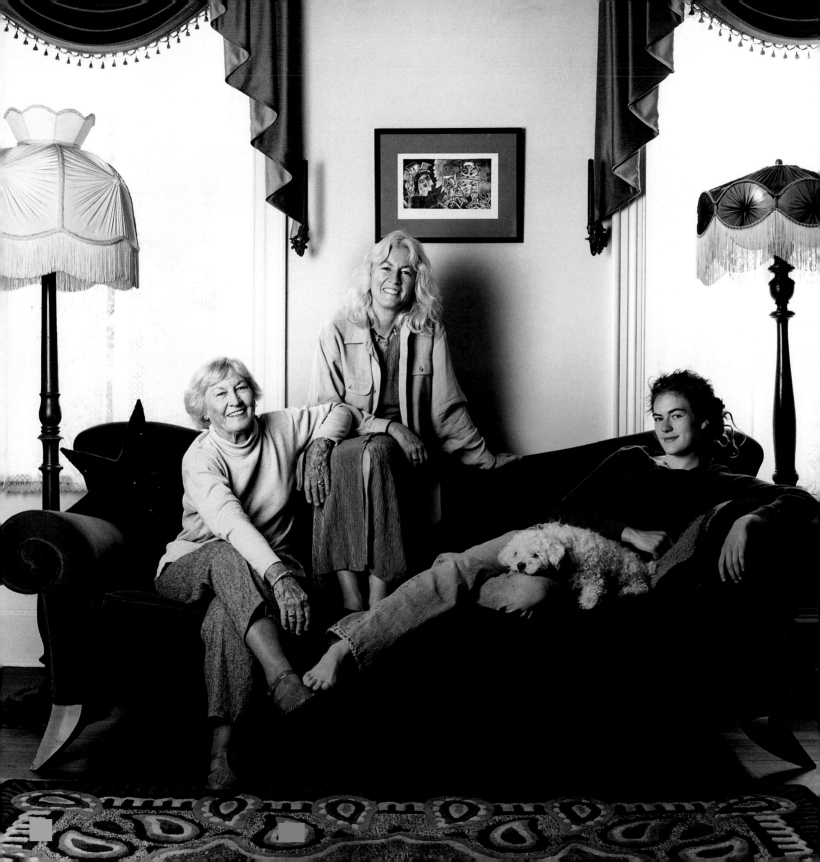

"We're always opening the door to the next generation."

BETTY WICKS, 1922

JUDY WICKS, 1947

GRACE WICKS SCHLOSSER, 1979

For three generations of Wicks women, social awareness and a strong sense of community has been a driving force. Betty Wicks was a schoolteacher and a Girl Scout leader. Judy Wicks is owner of the White Dog Cafe in Philadelphia, a place where social activism and good business mutually thrive. Judy's daughter, Grace Wicks Schlosser, is preparing for a future in environmental studies and dreams of one day living entirely off the land.

BETTY WICKS

I was brought up to have a very orderly home and to be there when the kids got home from school. So when Judy decided to have a restaurant, I said, "You can't do that, you have two children!" And she said, "We'll be right upstairs." That was just beyond anything I could think of. Then she said, "I'm going to call it the White Dog Cafe," and I said, "Not White Dog—that doesn't sound sanitary!"

So, don't listen to your mother!

I'm proud of Judy. We're all strong. Grace, particularly, is extremely independent. When she was two, she was going to a day camp with a bag of diapers over her shoulder. I really have a very special relationship with Grace, and part of that is because Judy's been so busy. Grace comes to see me in the summer and I have her all to myself. Grandparents don't get acquainted with their grandchildren when Mom and Dad are around. I've been privileged to watch her grow up.

My mom and dad's generation and my generation weren't big on praising their children like I see my children do. But I knew my parents just thought I was swell. And I think that gives you so much self-assurance.

Judy reminds me of my mother. She has this great laugh, and sense of humor, and sense of fun—more than I do. My mother's philosophy, which she really drummed into me, was, whatever your job is, do it cheerfully and willingly. And I've always tried to be that way. I've always believed in community service. I did it in my own way, in my own generation. I hope I passed on a sense of community and an awareness of others' needs.

JUDY WICKS

I associate my mother with happiness. I had a happy childhood, and she was a happy person and an extremely liberal parent. She basically allowed me to do whatever I

81

wanted. So there's a sense of trust that I didn't betray—not that I was Goody Two-Shoes! I was always mischievous. But I never did anything evil or mean. And I think my mother knew that. She never tried to control me.

When I was little I was very entrepreneurial. I remember the first day we moved into the house where I grew up. I was five years old, and there was a long driveway and I didn't know anybody in the neighborhood, so I got out this toy record player and a whole bunch of extension cords. I ran them down the driveway, put a record on full blast, and sat in a little chair and waited to see who I could attract. I think, in a sense, that was like my first restaurant. I didn't have any food, but it was that idea of bringing people together.

The business is my greatest achievement. Just being able to create something real out of a vision, making something out of nothing. I never went to business school, and I'm kind of glad. Because business school tends to teach you to leave your values at home when you go to work. I live in the house where I work, so I never really see any separation between the values of work and home.

If it came down to my kids versus the business it would be my kids, but I guess there were times when I chose the business. I put more time into the staff Christmas party than Christmas dinner for the family. I guess I always had guilt about that. On the other hand, I was always around in some capacity, even if I was distracted.

I think that each generation in our family has pushed the envelope in terms of what women can be allowed to do. My mom was the Girl Scout leader in our town and a public school teacher. And my grandmother, I know she thought it was weird that my mother would go on camping trips with girls. And then my mom thought it was weird when I started running a business and that I traveled a lot without my husband.

What I see as being different about our chain of women is that we're always opening the door to the next generation, not expecting our daughters to repeat our own lives. My mother allowed me to evolve from where she was, and I allow Grace to be more evolved than I am.

Grace is like a totally liberated person. When she was ten, I took her to Nicaragua. I put together this group of people—they were part of our White Dog Sister Restaurant delegation. I was too shy to say anything before the group. And we were on the bus on the last day, and suddenly my daughter just got up in front of everybody and said, "I would like to take this occasion to thank our tour leader for the wonderful job he's done, and our bus driver for driving us safely through these mountain roads." She knew it was appropriate. Seeing her do that started to give me the courage to do similar things.

Grace has left me in the dust in many ways. And I'm not the least bit threatened by it. I'm proud of it. And I know my mother's proud of me.

GRACE WICKS SCHLOSSER

My mother and I share a common vision of society being able to get better. From my mom and my grandma I think I've inherited an ability to see the best in people—seeing their full potential and working with that.

Grace Wicks Schlosser (left), Betty Wicks

I think my grandmother always trusted my mother a lot. My mom had the freedom to do what she wanted to do, and my mother's taken the same approach with me. It's partially because she's very busy, but she also trusts me to do what's right. It's a view towards life—people will do the right thing if you give them an opportunity.

I left prep school and designed my own environmental studies program to find out what the socio-environmental crisis is and what can be done about it. I think I'd like to be a writer, and I definitely would like to live as self-sufficiently as possible. That means growing my own food, having natural systems of water purification on site. I think of being in contact with people over the Internet, and maybe having a school near my house so that it's part of a community.

Parents are usually very overbearing. If a child has some beautiful, far-fetched ideas, they're usually shot down. But my mom didn't do that. I look up to my mom a lot. She's definitely a very important role model to me. I'm very lucky.

"I went around school saying I was a child of choice, not of chance."

ESTHER GRAITZER, 1916
SANDY JOSEPHS, 1940
LINDA FORMAN, 1946
CAREN JOSEPHS, 1967

Linda Forman was a child of the sixties who wanted the experience of giving birth but didn't feel prepared to raise a child. She did insist on participating in the choosing of the adoptive parents, however. She and the agency decided on Sandy and Richy Josephs. Twenty-one years later, Caren Josephs searched for and was reunited with Linda, her birth mother, and Stephen, her birth father.

CAREN JOSEPHS

I was told I was adopted before I even knew what the word meant. I went around school saying I was a child of choice, not of chance.

I have an older brother and a younger sister. My brother is adopted and my sister isn't. Some people could say that she was an accident; we say that she's a miracle.

I definitely noticed what my sister had in common with my parents, but I had similarities, too. My mom's an artist, she gave me pastels; my dad taught me how to play guitar. I mean my whole life has been wondering whether it's environment or genetics. I've seen a whole lot of evidence for both.

I have the most wonderful relationship with my family. I love my parents to death, and they knew that my search wasn't out of a longing for another parent. They were only worried that I would be hurt, and that was a risk I was willing to take. For all I knew, my birth parents could be dead, or they wouldn't want to see me; I mean, you have to be prepared for anything!

At eighteen, the agency will give you certain information. They told me her name was Linda, his name was Stephen, and that she had curly hair. I remember thinking, "I have curly hair. Cool."

At twenty-one we could officially start the search. I had graduated college, I was living in Hoboken looking for work. The same day I got a job, the agency called and said they had found her and that there was a letter for me. It was basically a history of Linda's life and how glad she was that I'd looked for her. Her second letter told me about my birth father. He and I started writing—he wanted me to know everything.

The meeting was in a hotel. I went up the elevator and stood at Linda's door for a couple seconds before I could actually knock. When she opened it we just hugged and cried and laughed. We sat in that room for five hours.

PAGE 84 *Caren Josephs*

Stephen came later. He's really sensitive and sincere and sweet. Linda is more rambunctious—I would say that the outside of me is like Linda and the inside of me is like Stephen. That night we were going out dancing, and we had both brought a navy and white polka-dotted dress. It was unbelievable! There's like thousands of things we have in common. Whenever both of us read, we hold a highlighter in our hand. Like the stupidest little things.

The next day I introduced them to my parents. They were nervous but it was wonderful. My brother and sister both were here and it was a great day.

I've been very aware of the way my mom raised me, who my birth mom is, what they've taught me. When I have kids, I want them to know all these people that have influenced me.

SANDY JOSEPHS

I had two pregnancies. Neither baby survived. Richy and I decided to call the Association for Jewish Children, and were told that we might have to wait up to seven years. And so we went for our interview, and the social worker, she loved us. I'm convinced of it because we got our approval and we got a call that we had a son and it was so fast.

We had nothing in the house. Everyone ran around shopping. This one went for curtains, this one went for a crib, and we put together a room in a day. The social worker came to visit us during that first year and said, "Sometimes we let you adopt a second. But you can't apply until your first one's two years old." So consequently they're two years and three days apart!

When you go there and they put the baby in your arms, it's the most wonderful sensation in the whole world. And having later given birth to a child, I can honestly

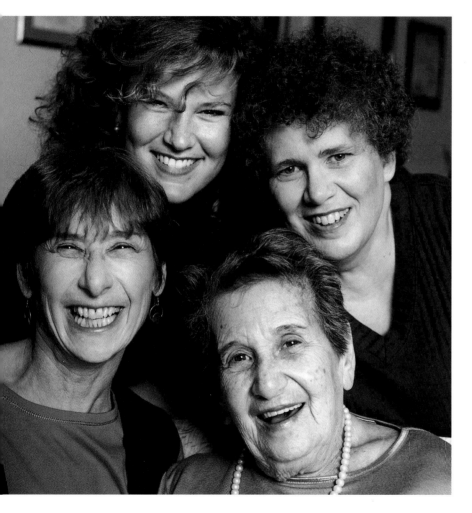

Clockwise from top left: Caren Josephs, Linda Forman, Esther Graitzer, Sandy Josephs

say it's no different. It was no different than when Susan was born and they handed her to me in the delivery room. It's like, "This is mine."

Caren and I were not friends. I'm the mother. Until she was about four years old, Caren had no fear. Once she had a tea party with lighter fluid. She broke two front teeth, put her hand through a storm door. The first day we belonged to a swim club, she was face down in the pool before we could turn around.

Now Caren's a people person and a kid magnet. She's got fabulous qualities. Don't mind me bragging. I told Linda, "This is really nice to have somebody to brag to who can brag right back." My children give me more joy than words can say. Not that I haven't wanted to kill them all.

LINDA FORMAN

I was twenty when I came back east from California. I was living with my family and it occurred to me that it was going to be my only opportunity to have a baby. Stephen was around and I thought he would make a good dad person. And I couldn't have put it into words before, but when Caren asked me why I had her, I said, "Because you wanted to be born."

I never thought of myself as being capable of raising a child. I rode motorcycles and took drugs. I couldn't keep a plant alive. So the trick was, once I got pregnant, to find the right parents. When we found the Josephs they were like—well, they fit my picture of the family that was supposed to get Caren, and obviously they were.

When Caren was born they mutely brought her to my room. She was the cutest thing in the world, and the nurse tried to give her to me and I said, "I can't hold her." That would have been the end of it, if I'd picked her up.

Once she was adopted, I knew everything was going to be fine. I didn't expect to hear from her for eighteen years, but I completely expected her to find me.

What I dreamed for her was that she would grow up in a healthy and happy and loving family, around people who encouraged her. And she got it. This is a great place with wonderful people.

I don't have any regrets. I would have been a terrible mother; being a mother is being there when your kid has knee surgery, and getting up in the middle of the night when the baby cries, and being there when they don't make the softball team. Being a mother means Sandy. I'm very comfortable with Caren being my kid, sort of; my friend, really, and my sort of weird niece in New York. It's great.

"Women should be wonderful homemakers and mothers, but they also need a life of their own."

ROSALIND CLARE ("RA-RA") MCLAURY, 1902

SUZANNE ("SUE") SPEAR, 1926

LAURINDA SPEAR, 1950

ALISON SPEAR, 1959

MARISA R. FORT, 1980

CAROLINA, 1996

On the occasion of Rosalind "Ra-Ra" McLaury's ninety-fifth birthday, a group of women gathered in Miami to celebrate, including Ra-Ra's daughter Suzanne Spear, an actress, aviator, Zen Buddhist, and mother to Laurinda and Alison, two well-respected architects with distinctly opposing lifestyles.

RA-RA My mother was a very elegant lady. What I know about china and crystal and so forth, I learned from her. The way she ran her household was always in perfect taste. She really left a legacy. I am trying to pass down table manners, and everyday nice manners, which you do not see in the children of today.

MARISA Ra-Ra was really formal. And then Sue was a lot less formal, and then you jump back to Alison, she's very formal.

SUE I grew up in a house that had servants, never picked up after myself, never did any cooking. But early on, Laurinda and Alison started cooking and had a sense of housecleaning. Alison now thinks I'm very disorderly.

ALISON My mother was kind of the hippie in the family. She wears jewelry she finds when she's jogging. She wears things that hold pipes together as jewelry—what are those things called? Clamps? Today she had one Tic Tac for lunch!

LAURINDA I think Sue brought us up in a very informal way. And I'm trying to bring my children up in a slightly more formal way—like having seated dinners. If you don't do that, then you have real savages—it's like *Lord of the Flies*. If I'm not there, it's a disaster!

ALISON Laurinda's the ideal woman.

MARISA She's like superwoman. She takes care of six children, she has a firm, she cooks dinner every night. She actually bakes bread! She woke up at 4:15 this morning, ran fifteen miles, came back, got all the boys dressed, took them out to lunch at the Yacht Club, came back, got her running shoes. She does everything!

LAURINDA That wasn't that hard.

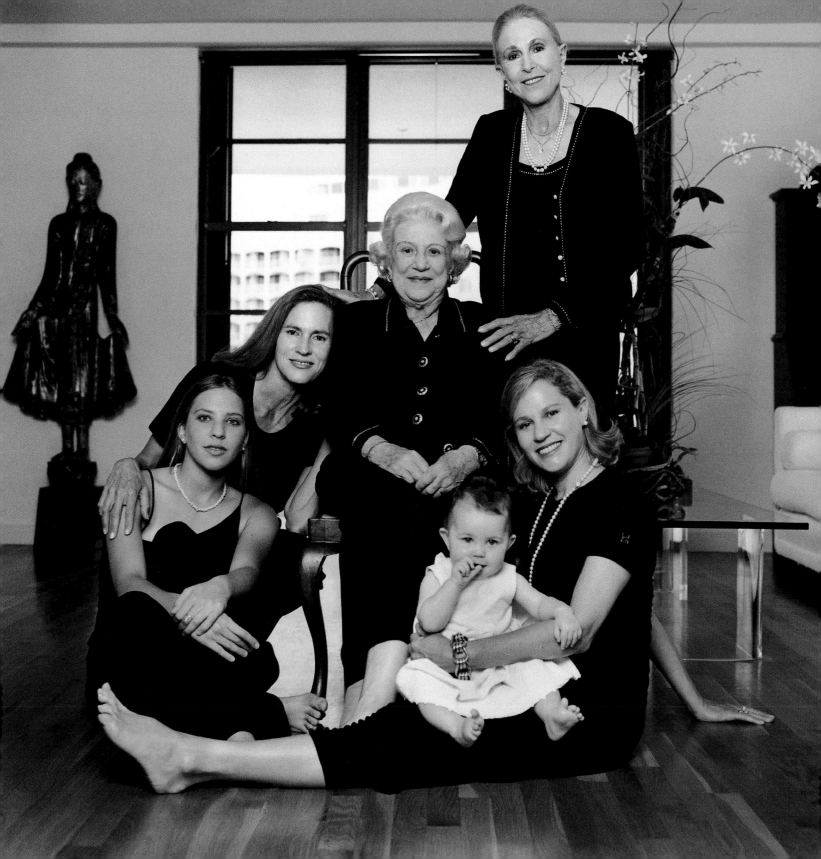

PAGE 89 *Clockwise from top: Suzanne Spear, Alison Spear (holding daughter Carolina), Marisa Fort, Laurinda Spear, Rosalind Clare "Ra-Ra" McLaury*

MARISA Yes, it was! 4:30!

LAURINDA The most important job is to keep everyone alive!

ALISON She says that all the time, like we're in a war or a concentration camp.

LAURINDA Growing up it was a different situation for us because my father worked really late, my mother would always have dinner with him, and we were sort of left to the housekeeper.

ALISON See, that's where I'm more like Mother and Dad. I try to be as calm and relaxed about parenting as possible, and I also try to preserve the original relationship that I had with my husband before I was a mother. Which I think I got from my grandmother. Because she was best friends with her husband, and really separated that from motherhood.

Suzanne Spear

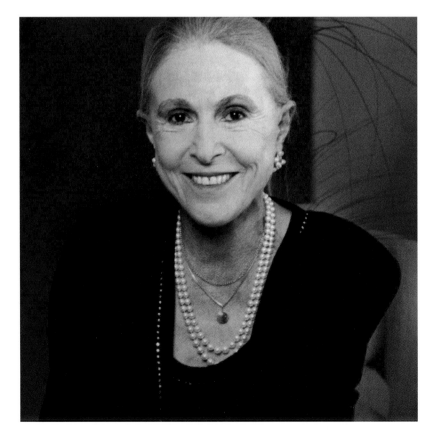

90

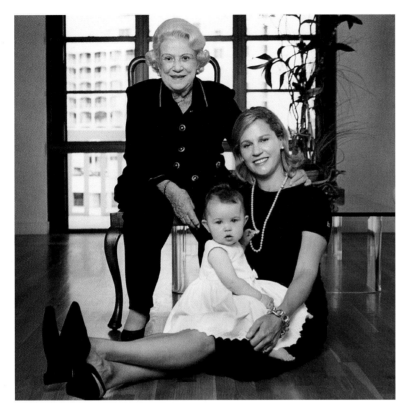

Clockwise from top: Rosalind Clare "Ra-Ra" McLaury, Alison Spear, Carolina

RA-RA Alison once said that everything she ever learned about gracious living she learned from me. And that was a big compliment.

SUE My mother's a great hostess, she loves people, she has done so much for her community—you name a charity. She played golf until she was ninety. And she's still living in her same lovely house.

ALISON Ra-Ra spends almost every weekend with Laurinda and the kids. She's prim and proper, but totally tolerant. The boys play drums at seven in the morning and she doesn't care!

SUE Laurinda originally wanted to be an actress. I was the one who said, "Did you ever think about being an architect?" and she picked up the ball and the rest is women's history. Laurinda and Bernardo built our house, the Pink House. And not only did it shock us, it shocked the country and the world. It was a landmark building. Living there for twelve years was like a constant—what shall I say?—it was like a museum. We had visitors, societies used it for fund-raising, we had *Miami Vice,* we had a zillion commercials. Alison told her school, "I'm going to be an architect, just like my sister." Now Marisa is going to apply to architecture school.

LAURINDA In many ways, Marisa's in a better position than I was because she's much more international. She could work in a different country and not be an outsider. So she always has the choice.

ALISON I'd like as many opportunities as possible for my daughter. There are so many people you see that are in niches—I'd like her to be more in the world, to have skills and be confident.

SUE Women should be wonderful homemakers and mothers, but they also need a life of their own. Right? Like Virginia Woolf—a room of their own.

"I'm a mother to the surroundings, the livestock, the animals. I'm like the ruler, the emperor, the saint."

GRACE HENDERSON NEZ, 1912

MARY LEE BEGAY, 1941

LENAH LEE HENDERSON, 1969

Lenah Lee Henderson grew up on a Navajo reservation in Arizona. From her mother, Mary, and her grandmother Grace she learned the Navajo language, Navajo traditions, and the art of weaving. Lenah is the first of the three to speak English. She translated her mother's and grandmother's words for this book.

LENAH LEE HENDERSON

Grace Henderson Nez is my grandmother. Her mother and grandmother taught her to weave when she was five. She said she used to make it real simple. No designs, just stripes and wide bands. She learned how to spin the wool and card the wool, and wash and clean and how to dye it.

She said her grandmother told her to weave no matter how hard it may be, no matter how tired, no matter how lazy you are, continue weaving. It's going to give you income, not just to yourself but also to your children in the years to come.

She says, "I'm not just valued by being a mother to my children, my grandchildren, my great grandchildren, I'm also mother to the Navajo people."

Mary Lee Begay is my mother. She was raised in a large family, and she was the only female. She said her brothers were all sent to school, but she wasn't. Her mother and father told her, "You're going to stay with us and help us with the house chores."

She's still upset about that; she even cried about going to school, but it never happened. She says she's embarrassed that she doesn't have the tongue to speak English. She said sometimes she thinks about taking courses, and she kind of laughed about it in a way. She said, "I'll probably be the oldest lady in the kindergarten."

She was taught the traditional way of life, the Navajo way, how to present yourself as a woman, how to carry yourself, how to set rules for yourself, how to discipline your children. From the time she was small she was taught how to weave, and to this day she keeps up and she says she doesn't want to lose that. She was just taught the basics and as far as designs, it's from her own imagination.

She says, "When you're called a mother, it's very special. I'm a mother to the surroundings, the livestock, the animals. I'm like the ruler, the emperor, the saint."

My mother thinks it's all right to pursue something different, but she says to me, "You're going to come back. I guarantee you, you're going to come back and live out here and you're going to be a grandma, and your great-grandchildren, you'll teach them the same things we have taught you."

My name is Lenah Lee Henderson. Henderson was my grandmother's maiden name and also my mother's maiden name. It's something I wanted to keep for generations. The women are the head of the household, more than the men. That's how our

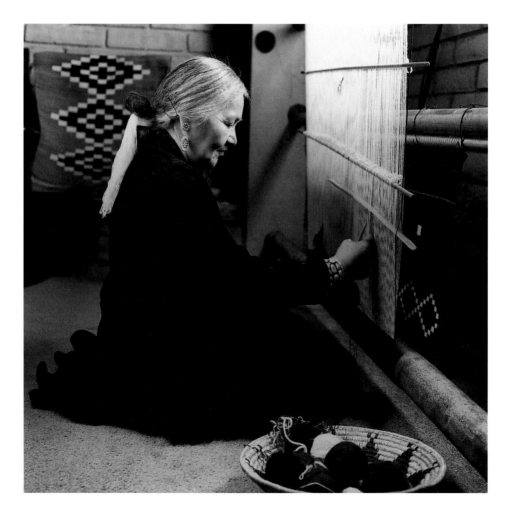

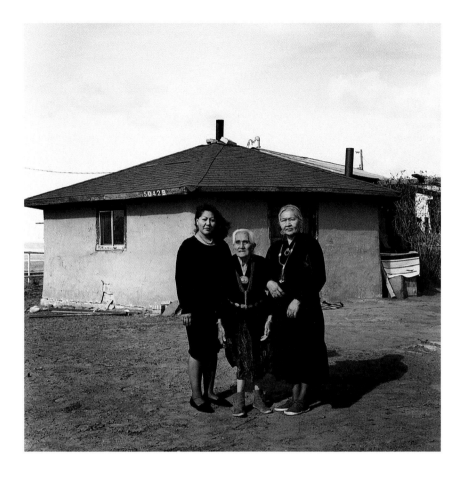

traditional values are. In the white world, it's different.

I attended Phoenix College right after high school, and I attended the International Air Academy. I've been back here since I had my son. Now I'm in the process of moving to Phoenix again. I'm in a relationship with Brian's father; he's working in Phoenix. He's Afro-American. He likes this place, pretty much. If there were jobs out here, he would live here. But the economy on the reservation, it's not good.

My mother thinks I'm lazy when it comes to weaving, but I'm going to come back to it. It's something we treasure, but we're so much into the outside world, pursuing our education, work—we have to provide, and that's a priority for my sister and myself. So it's not that I'm too lazy. We strongly believe the Navajo tradition. My grandmother, she always said, "Don't speak English, speak Navajo." My son speaks Navajo. Not as much as my sister's daughter.

Left to right: Lenah Lee Henderson, Grace Henderson Nez, Mary Lee Begay

I really blame myself for that, but it's never too late.

As far as dealing with the Navajo society, I mean, there are taboos, there's a structure. You're not supposed to talk dirty. Obscene language—that's not being a Navajo. You're not supposed to get drunk, or commit murder or suicide, and you're not supposed to be wearing shorts cut all the way up. Navajo men are not supposed to go around and use a woman or disrespect a woman.

My mother taught me what's right and wrong, how to stay focused on who you are. When it came to dealing with the outside world, I had to figure everything out on my own. In a way it's very difficult, and then again I'm really grateful for who I am, and it made me a stronger person.

"I really want Maia to grow up to be this independent person. She feels her safety is at stake, so it's a difficult balance."

ANNE REIF, 1905

MARILYN COOPER, 1934

SHAWNE COOPER, 1957

MAIA COOPER PILLOT, 1990

A food allergy can be as mild as a slight rash brought on by eating too many strawberries. Or it can be a potential killer that hides in a multitude of disguises. Every day, Shawne Cooper lives in fear that her daughter, Maia, will come in contact with something made from peanuts. She has parlayed that fear, as well as her new-found knowledge and steady strength, into a campaign to help other parents and kids cope with severe food allergies.

SHAWNE COOPER

Maia was two-and-a-half when she had her first peanut butter sandwich. She said, "My tongue itches." I called my pediatrician because you never know, and he said, "Maybe she's allergic, don't give her any more for six months or so." We forgot about it, and that was that. Then when she was going into kindergarten, she went to a different pediatrician and she asked if she had any allergies, and I said, "Peanuts, I think," and she said, *"What?"* We found out that Maia is seriously allergic. A few months later we went to visit my parents and my mother kissed her hello. Twenty minutes later the whole side of Maia's face was buried in hives. What had happened was that hours earlier my mother had eaten an apple slice with a smear of peanut butter on it.

We wrote a letter to everybody in Maia's grade asking them if they would mind refraining from bringing peanut butter sandwiches or anything with peanut butter for lunch. I tried to make it light, but get the point across.

We've only had one anaphylaxis incident—that's when the throat starts closing up. I had taken Maia and her brother to lunch at this fancy deli. Maia ordered roasted chicken and homemade potato chips which they said were cooked in olive oil. And when we sat down to eat, Maia said, "I smell peanuts." I told her it was fine, and when she took a bite of the chips she said, "I feel really weird." Sometimes she panics when she's not sure something's she's eaten is safe or not. But I saw from the look on her face that this was different. I realized this is it, I have to give her the EpiPen, and all of a sudden I didn't trust myself and so I was shaking and trying to read the instructions and finally I just gave her the shot on the side of the thigh, called 911, and picked her up and carried her out on the street. She was seven. If I hadn't given her the EpiPen right away, there's a good chance she could have died.

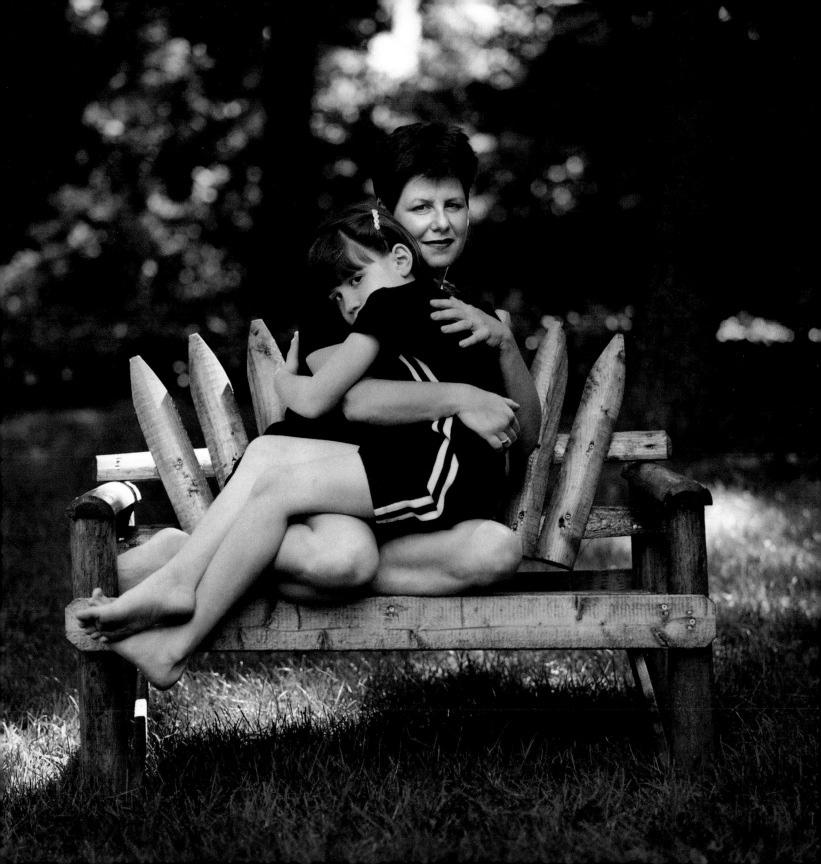

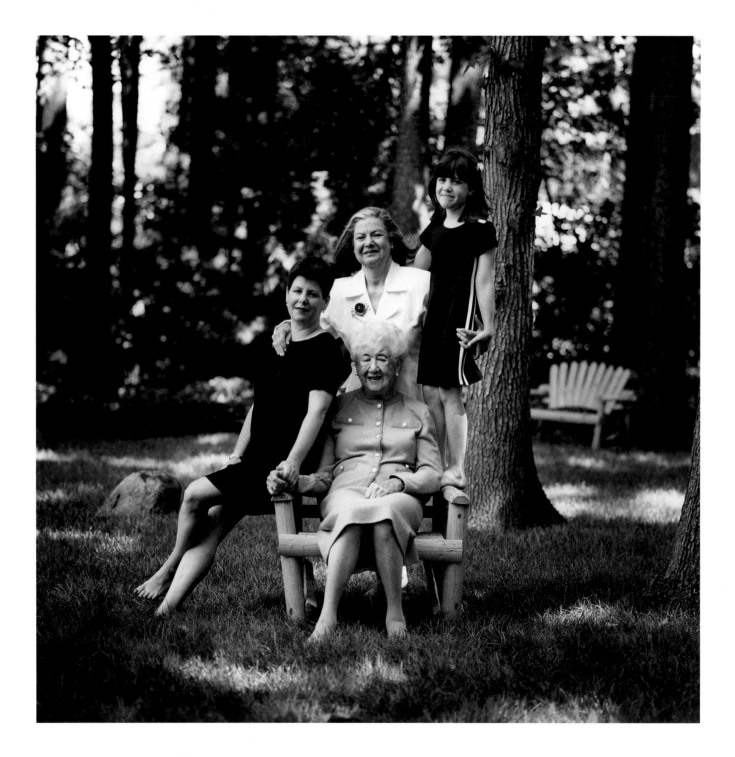

My relationship with Maia is complex, symbiotic. I feel that she relies on me as her number one safety net. It's a challenge, because I really want her to grow up to be this independent person. She feels her safety is at stake, so it's a difficult balance.

My biggest support person is my mother. She's the one who taught me to question doctors, to question authority and dig deeper and become an expert. And I go to her for emotional help. She always gave me the space to show my emotions—even during my tumultuous teenage years we'd argue, and afterwards we'd be crying, hugging, laughing, letting it all hang out. It's very important for me that Maia gets that concept— to be authentic and always true to herself.

I believe it's up to us to create a world that we want our kids to grow up in. That's what I strive for, to show by example and not let fear stand in the way.

MARILYN COOPER

My mother taught me to be independent. She looked upon me as an adult; I was allowed to go on the subway when I was eight or nine. She showed me how to take a chance. And Shawne, too, was never afraid to leave her comfort zone. She would never let me protect or shield her from dangerous or unpleasant situations.

Shawne had her own mind at a very young age, and so we had a lot of friction. Then, at one point, I guess I made up my mind that I would concentrate on the important things and not worry about the small things. That made our relationship much more pleasant. I respect her as a wonderful woman. I think that when she sets her mind to it she can really do anything.

When Maia was diagnosed with her allergy, Shawne found the most knowledgeable allergist; she followed every lead and became an activist among people with similar problems. I am just so proud of her, of the woman she has become. I can't believe what a wonderful mother she is.

I want Maia to be a little girl and not grow up so fast. It is an enormous burden for her at eight years old to know what death is—she's afraid she's going to die. She thinks so much about what can happen to her. Whatever is in my power, I would like to create a safe world for Maia.

MAIA COOPER PILLOT

My mom is the best mom. She helps me when I am so scared and hugs me when I need a hug.

99

"I find myself with a great feeling of lightness and joy, thinking, 'I've found a way to make my life work.'"

LUCILLE KEENEN, 1921

CHRISTINE KEALY, 1944

COURTNEY KEALY, 1967

Christine Kealy is a doula—one who takes care of new mothers— and heads a Manhattan company called In a Family Way. She found her calling at the age of forty-four, shortly after having reared three children, and long after having grown up in a household with seven siblings and a mother whose exacting standards were loosened completely in the presence of babies.

CHRISTINE KEALY

My mother was twenty-two when I was born. She wore loafers and plaid skirts, and I thought she was just the most beautiful thing on the face of this earth. She always wore Chanel. When she was going out she would kiss me good night—I remember dotted Swiss evening dresses and bird-cage earrings.

But she was strict, very strict. Strict bedtime. Strict mealtime. Strict manners, politeness. Her mother was a flapper, she hadn't had structure in her life, so she had a predetermined idea of what she wanted her house to look like, what she wanted her children to wear. She was also a very strict Catholic, so we had rigid moral rules.

I became kind of her helpmate with the younger children. There were eight of us, so there was always a baby in our house—when I was four, six, eight, ten, right up until the time I was sixteen, when my last sister was born. I left for school when she was two.

I have always loved babies. Whatever stresses and strains were going on, there was a high chair at the table and it was, "Let's see if we can make the baby laugh. Let's sing Happy Birthday to the baby." My mother could be screaming at everybody in the house and tooting the horn for us to come out and get the groceries and—you know, there was a buzzer in on the top floor and she'd really hit that thing—but she never let it show with the baby. There was something magical about the baby's world.

I got married at twenty. I dropped out of college and didn't complete it until I was thirty. But my parents never put much of a priority on education for the girls. Sometimes I think it was Victorian days. We had to take sewing lessons, dancing lessons, piano lessons, but we weren't supposed to be good at any one thing.

My husband and I got married in September, had a boy in August and thirteen months later we had Courtney, so that kind of knocked my socks off. I remember

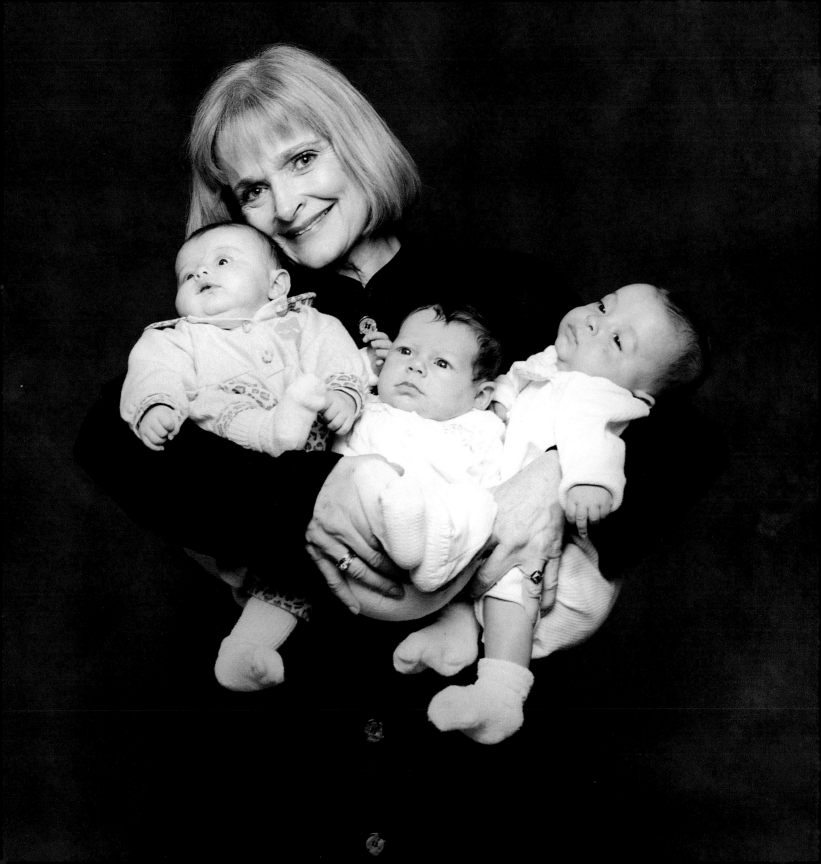

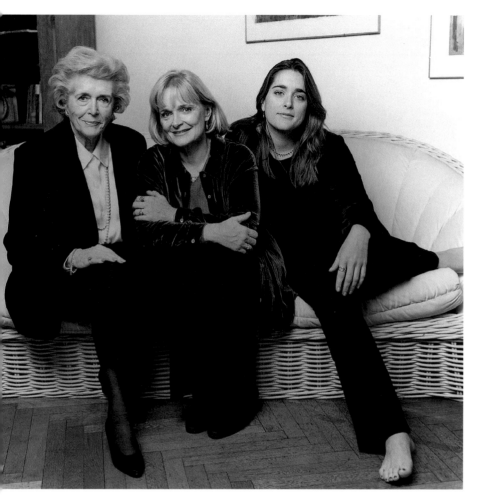

going to a priest and saying, "I really need to practice birth control," and he said, "That's a mortal sin." We were going through all those turbulent end-of-the-sixties changes. I went from a little housewife who wore suits every day to, you know, growing my hair to my waist and putting on a headband.

By 1971 everything that I had believed in was gone—the church, suburban life, the family. I moved with my husband to New York, and three years later we ended the marriage. Reality hit when I got my first job. I spent four months wadding up pieces of stationery and putting them in my bag to take home because I had made mistakes. I was fired. And then I proceeded to be fired by the next six men that I worked with. I'd start a new job and say, "Oh, my children are no problem." And then they'd be on the phone—"Ben threw an egg out the window," "Sean's at the emergency room, he hurt his ankle"—and I'd be sitting in some office, whispering, "Do you think it's broken?" Between that and no experience whatsoever. . . . One man said I had ruined his office, ruined his ledger, ruined everything.

Then I got into sales and it was horrendous.

ABOVE *Left to right: Lucille Keenen, Christine Kealy, Courtney Kealy*

PAGE 101 *Christine Kealy with three of "her babies"*

I cried every day for twelve years. Every time I started to make money they would fire me, and the children would make me dinner and say, "We love you Mom, come on, you need a nap." And then I'd hear the doorbell ringing wildly and it would be a neighbor, saying, "My husband's going to have a heart attack if you don't stop playing basketball above his head." Or, "You ruined my clothes throwing water balloons out the window. I'm going to kill you." It was like totally out of control.

There were years of shock when I think my mother was ashamed of me. My parents thought it was awful that I was raising my children in New York, they thought it was awful that I was divorced and that I worked. Everything that we did was interpreted as having been done to them.

102

I remember reading that if you can let a child know that no matter what they do you will be there for them and love them, you will have been a good mother. That was an astounding notion because it was contrary to what the creed had been for me: "If you do what we want you to do you will please us." And I wanted Courtney to know that there was no agenda, whatever came out of her I would be proud of. She's always been able to speak her mind and put her little hand on her hip. We would clash, she would yell at me, and I would just let her do it. We came out of it with a relationship—it's been wonderful.

My youngest child left for college just as my older two graduated, and I was heartbroken. I'd spent twenty years learning how to juggle job and family, and now the family was gone. I felt very empty and lonely and I said to Courtney one day, "You're so lucky that you're young and you can do whatever you want." And she said, "There's nothing you can't do, you're only forty-four." It was an enormously significant moment. I mean, both my grandmothers sat by the window for twenty-five years. After Courtney said that there was this enormous switch in my consciousness.

I made an inventory of my skills, but I did it with a very jaded feeling of, "Oh great—I'll be the world's oldest mother's helper." And I absolutely believe that there's a force in the universe and if we plug into that we can ride the tailwind. Sure enough, I went for a massage and I was telling this woman what I wanted to do and she said, "Oh. You know there *is* such a thing. It's called a doula." And I went home and I drew my logo on a napkin. I just knew.

That was 1990. I got myself a client, and I loved cooking for her and surprising her and showing her different ways to hold the baby. The first year we had eight babies. This year we've had two hundred and thirty so far. Which also made me feel that I had really plugged into a need.

When I started this company, because it was about mothers and babies and giving, somehow or other my mother started to acknowledge that I had a soul. I give her a lot of credit. She did change. She really did.

I find myself with a great feeling of lightness and joy, thinking, "I've found a way to make my life work." I mean, I never could imagine being self-supporting—I almost thought it would be unfeminine: "Oh my God. I'm in charge of me? Where's the man?"

I feel rich beyond all belief. My daughter loves to spend time with me, she calls me fifteen times a week, always crackling over the wires from New Guinea or somewhere, and I'm blown away. She's everything that I would have wanted to be if I had started out younger.

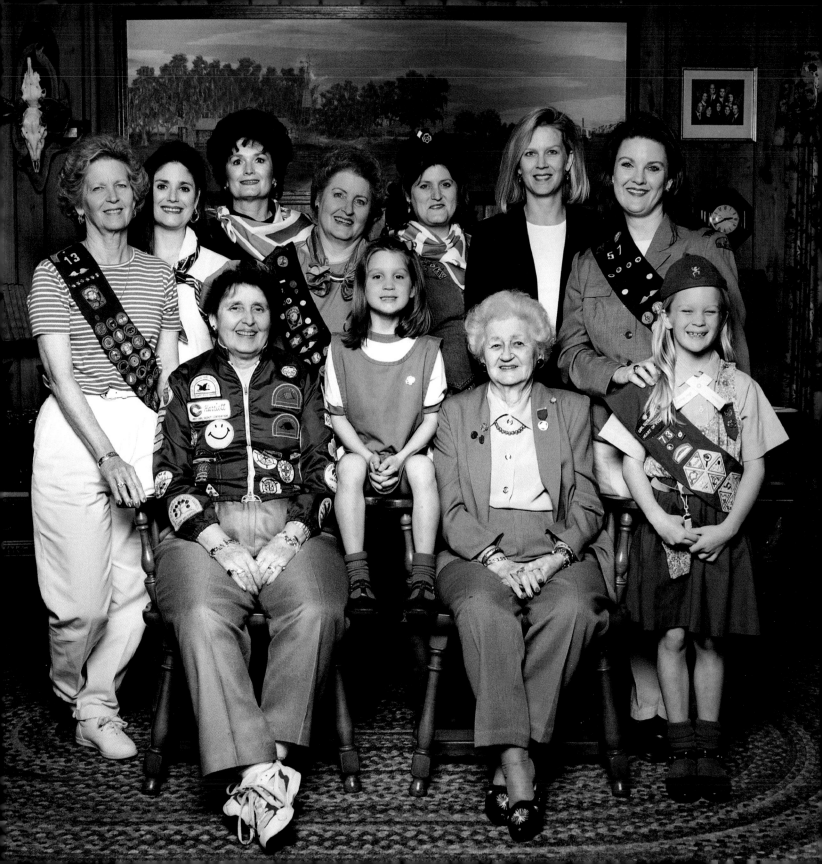

"My daughters are all leaders.
Every one."

**LAURA FRANCES
"SWEETMAMA" MULCAY,**
1914

**HARRIETT GRIFFIN
HARRIS,** 1934

**SARAH JANE GRIFFIN
ALEXANDER,** 1936

**LUCY ANNE GRIFFIN
COLLIER,** 1940

**NANCY ALEXANDER
CASWELL,** 1963

**CYNTHIA LYNN
MATTESON,** 1963

*Peace River Ranch, in the heart of
Florida, has been the site of many
a Girl Scout camp-out. It is also
the summer home of the Griffin
family, whose female members
have more than 170 years of
scouting experience between them.*

LAURA FRANCES "SWEETMAMA" MULCAY

My parents taught me to be honest and trust in God. My mother didn't preach to me, she just lived it. I had the happiest upbringing of anybody. The only thing I promised myself was that if I ever grew up, my children wouldn't have to take castor oil!

I had four children, three girls and a boy, and then after nine years, here comes Francie. She's a missionary, she's traveled all over the world. My daughters are all leaders. Every one. When they promise to do something, they do it. And they have carried that over pretty well into their children.

The ranch has been wonderful for the family. We've spent summers down here, and we opened it up for the Girl Scouts and the Boy Scouts for camping. Scouting had done so much for me—it was my time to pay back. Our morals in this country are just so terrible; I feel like if more parents got their children into scouting or some good organization, we would not have the crime.

LUCY ANNE GRIFFIN COLLIER

Everybody adores Sweetmama. I wish I knew her secret for having the harmony that we had. If we had a problem, we'd talk it out. That makes for good peace.

I was a Scout from second grade till I graduated from high school. I really took the Girl Scout promise to heart. That's a part of my being; those words really struck a goal that I have in my life. I have one daughter, Cynthia. I became a leader when she was about four months old. In scouting you get to dabble and see, well, do you really like painting, or do you really like cooking? It makes my world more interesting because I have a little bit of knowledge about different things.

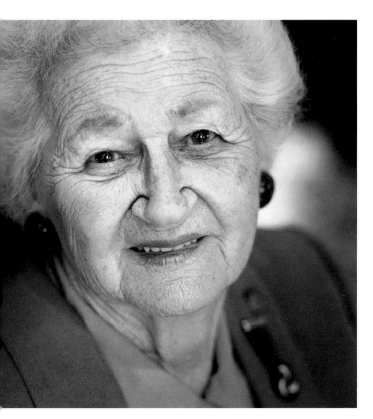

HARRIETT GRIFFIN HARRIS

I was a Scout during elementary and high school. Then I went to college and got married and we had Katherine. Katherine is now forty; Fran was born in '63. Scouting had a heavy impact on our lives because we believed in the Girl Scout promise: "On my honor I will try to love God and my country, to respect others, especially those at home." When our girls began to come in, I became a Girl Scout leader. It provided the happiest years I can remember; we still have the best time telling stories about what we did at our campouts, what we had to eat, and how nobody really wanted it, and you had to eat it.

SARAH JANE GRIFFIN ALEXANDER

I was a Brownie and a Junior Scout. You know, the Girl Scout laws are the kind of things I think our nation today is missing—"a Girl Scout is loyal and thrifty and honest and trustworthy." When I became a Scout leader, I really saw from an adult point of view what it was all about.

I have a son and two daughters, and I can say without reservation that they are quality people. And I like 'em. They're my friends. My daughter Laura Grace had cancer at age twenty-five, and she's taught me so much about how to deal with adversity. And Nancy was in a horrible accident, and what she went through, how she came back. . . . All my children have taught me.

NANCY ALEXANDER CASWELL

My parents have exposed us to so much. We were able to go to camp and learn to ride and shoot; we'd scuba dive and sail. My family does all this stuff and it just blows my husband's mind.

I'm very different than my mother. I'm far more outgoing and in a lot of ways, more self-secure. But you know, I respect what she accomplishes and I respect her; she's lived a lot more years than I have.

Motherhood is the most important task that God has enabled me to do—to raise three beautiful, precious children. I want them to have great memories.

CYNTHIA LYNN MATTESON

I adore my mother, I think she hung the moon. I keep telling her, "I still want to be just like you when I grow up."

My mother went through a divorce when I was in college, and I've learned through her that you just endure sometimes. You find the silver lining and get on with life. My grandmother's that way, too. She's a little bulldog. Our whole family is just kind of, lick your wounds and keep on goin'.

Harriett has MS now and she—she's really done well with it. It's a testimony to her that her daughter Katherine is a senator, running for secretary of state, her son has a restaurant in Aspen, and Fran is a writer and a real go-getter.

Just now Nancy said, "What are we going to say about scouting?" And I said, "Well, it wasn't anything different than what we were learning at home." We believe in all the things that scouting's about, but I think that the real center of gravity is our faith.

Left to right: Sweetmama,
Keaton Alexander,
Britton Alexander

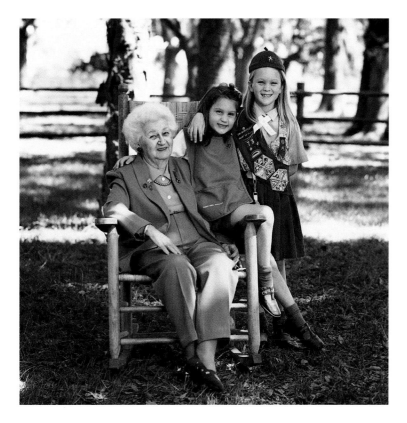

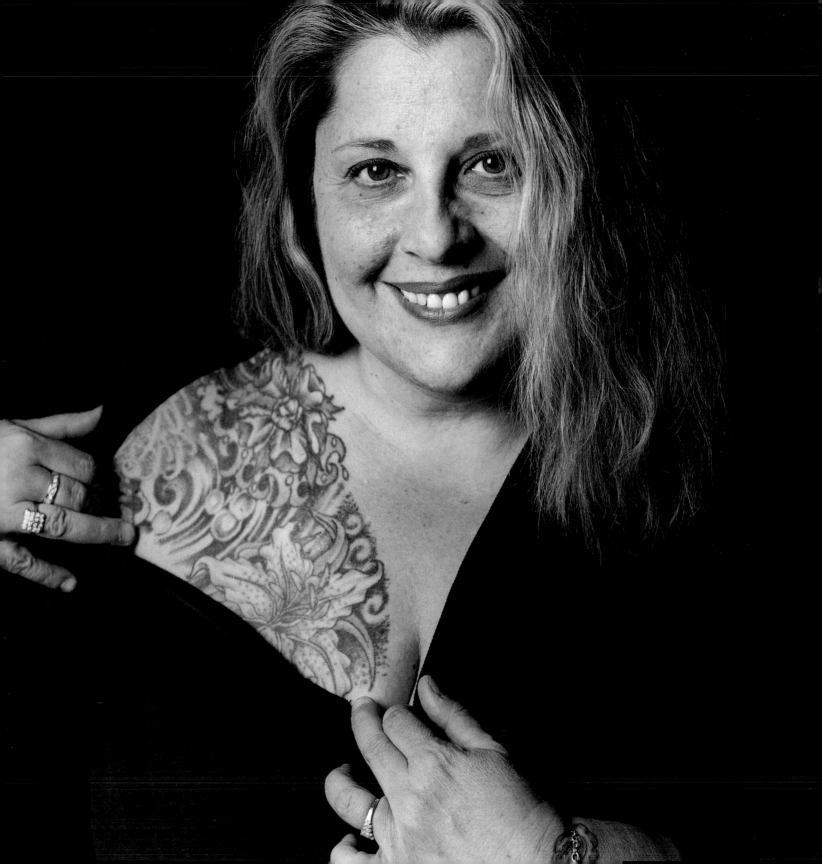

"I've always been from the school of, 'Yeah, you can buy me a diamond, but I'm buying a few for myself.'"

AURORA ESPERIAN, 1919

LOLA ESPERIAN, 1947

KIMBERLY ESPERIAN,
1968

Her husband left her when she was twenty-one and pregnant. Two years later she survived a serious cancer episode. Then the spirited Lola Esperian picked herself up, learned the art of tattooing, and opened Lola's Hot Flying Tattoo Studio. Her mother and daughter, although not "tattoo people," have supported her all the way, as have the clients and fans who visit her for advice, conversation, and a bit of body art.

LOLA ESPERIAN

I was on my way toward medical school, to be a surgeon, but then it seemed so dull and dry. I was looking for a vehicle to kind of do art and help people at the same time. Psychologically, you know. Get into them and have some fun. So I made my mind up that I was going to be a tattooist.

My mother had no interest in tattoos whatsoever. She got one, a little rose, solely because I had opened the shop—Lola's Hot Flying Tattoo Studio—and she wanted to be supportive. She screamed through the whole thing. No one has ever screamed as loud as she did. And she hates it, she covers it up with a Band-Aid.

My daughter also has a small tattoo, but neither one of them are tattoo people. I'm the oddball in the family. Well, okay, we have some things in common: we care about other people; we love family; and we're all big flirts.

For a tattooist, a relatively small area of my body is tattooed. I disapprove of facial tattoos because, as I tell my customers, that's God's territory. Our faces all look different already. Tattooing, like anything else, has a moral responsibility to it.

My tattoos are the story of my life. I would like to think that anything I put on my body would have been done no matter what field I was in. This one is a stargazer lily. It's the strongest flower. You know when guys buy chicks roses on Valentine's Day and the next day they're all dead? Well, I tell my male customers, "Don't buy roses. Buy lilies because when one dies, the next one opens." And that's what this represents. I have stamina, and I like to remind myself that I can last.

I had a pretty big cancer operation years ago, and that changed me. I was twenty-three, and sitting there at Sloan-Kettering was a wake-up shot. I should have been dead in a year. So I felt that, well, I must be alive for a reason.

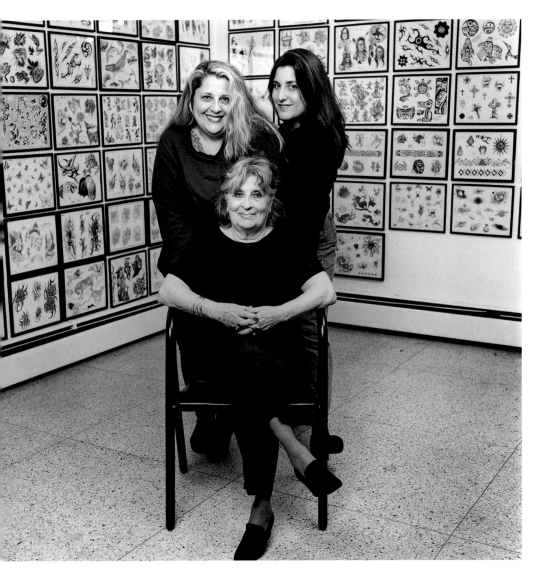

From my mother I learned that when things get really hard, only you can pull yourself up. She was divorced after twenty-five years; I was abandoned when I was twenty-one and pregnant. We were on welfare, my daughter and I. But we still always had the cleanest, nicest apartment.

When I was growing up my mother and I loved each other a lot, but we were at odds because we're so different. She was from the school of, "The prince will come, just wait." And I've always been from the school of, "Yeah, you can buy me a diamond, but I'm buying a few for myself."

Everyone has a big light inside of them and when you let it out, people can't resist. Even a plant will go toward the light. And instinct, that's another thing. Listen to it. I'm not afraid to change. I think that's what separates the girls from the women. I work on my daughter all the time, to get her to be more open.

My daughter is everything to me. I only had that one opportunity and it never came along again. She's the one person I'll always love, no matter what. And that's big, because you know, love fades. But not the love of your child, that cannot fade.

ABOVE *Clockwise from top left: Lola Esperian, Kimberly Esperian, Aurora Esperian*

PAGE 108 *Lola Esperian*

AURORA ESPERIAN

I had a wonderful childhood. I'm one of twelve; we were very poor, but we loved one another and we love each other to this day.

My mother was busy, but there were times when everyone else would go to bed and I would sit up and talk to her and see how she felt about everything. I wanted to be with her.

She was a great mother. Our clothes were always hand-me-downs, and by the time I got my sister's coat it was all tattered and I couldn't put my hand in the sleeve. So I said to my mother, "Can you sew this for me?" and she said, "No, honey, I'm so tired, I'm going to bed." So I felt, that's okay, I'll manage. I got up in the morning and the coat was all sewn! I ran to my mother and said, "Mom, when did you do this?" She said, "A little fairy did it." God love her!

I got married at sixteen. It was not a good marriage, but I had two beautiful children. Lola had a very bad marriage and was left alone, but the thing is that she wanted to be independent. So she went to some fellow up in Yonkers and she begged him, "Please, teach me how to tattoo." And she really was good at it. She had enough gumption to learn something and make her own business.

Lola and I keep in touch five times a day, without exaggeration. I have the same relationship with my sweetheart granddaughter, Kimberly. I feel very lucky because I see other children and they don't pay attention to their mother.

Lola and Kimberly go overboard. On my seventy-fifth birthday they gave me the most beautiful surprise party. There were about 150 people, they made me queen for the day. Crown and everything. Crazy.

KIMBERLY ESPERIAN

I'm a mixture of both my grandmother and my mother. My straighter side is from my grandmother, and I guess my ability to go with the flow is from my mother. Growing up there were no barriers; I was able to speak my mind, ask questions, and I was always answered.

I think the work my mother does is great. Not only with the tattoo part, but with the kids—she's helped a lot of teenagers. People come here just for advice; they can't get enough of her. Our house is constantly full. My friends would call her from across the world. My grandmother, too. We're all part of a triangle, a little witches' triangle. Good witches.

"Writing the book was a very important thing because there was no longer any, 'I'm big and you're little.'"

JULIE FIRMAN, 1919

DOROTHY ("DIDI") FIRMAN, 1949

SARAH SLAWSKI, 1977

Didi Firman and her mother, Julie Firman, are psychotherapists and coauthors of Daughters & Mothers: Healing the Relationship. *In the introduction to their book they write, "Being a daughter and having a mother is one of the most profound experiences of a woman's life." Didi's daughter, Sarah, says that while she adores her mother and grandmother, she is skeptical of their work.*

JULIE My mother was from Virginia, and very conscious of table manners and polite how-tos. I started out thinking that those were the most important things. But with Didi I realized that letting her be herself was more important.

DIDI Julie had been a schoolteacher, a principal, when I was young. She was becoming a therapist about the same time that I was. So when I was in my twenties, starting my first career, she was in her forties starting her second career. Right after I had Sarah, my mother and I started talking about mother-and-daughter relationships, and we would say, isn't it funny how these women always have these issues with their mothers? Ha ha ha. And that became an entry point for us to talk about our own relationship.

SARAH My mom is a fertility goddess. She loves children. She's a therapist, and I think that's the only career that would really fulfill her, but she's more a mother than anyone I know. I feel like the characteristics of her which go into her work are the same which go into her family. They're all part of the way she views the world.

DIDI Julie tells a story about how when she was in training, someone my age was teaching a workshop. Along the way she noticed, "Wow, this woman is twenty-seven, and my daughter is twenty-seven. Look at how respectful I am of this woman. I think of her as smart and not as a little kid," and so she made that translation. A lot of what our work is about is being able to come to each other as equals.

JULIE I think writing the book was a very important thing because there was no longer any, "I'm big and you're little."

DIDI The relationship gets better as Mom gets older. We still go through a lot of stuff—we cry and fight and moan, but we read each other a little better probably than

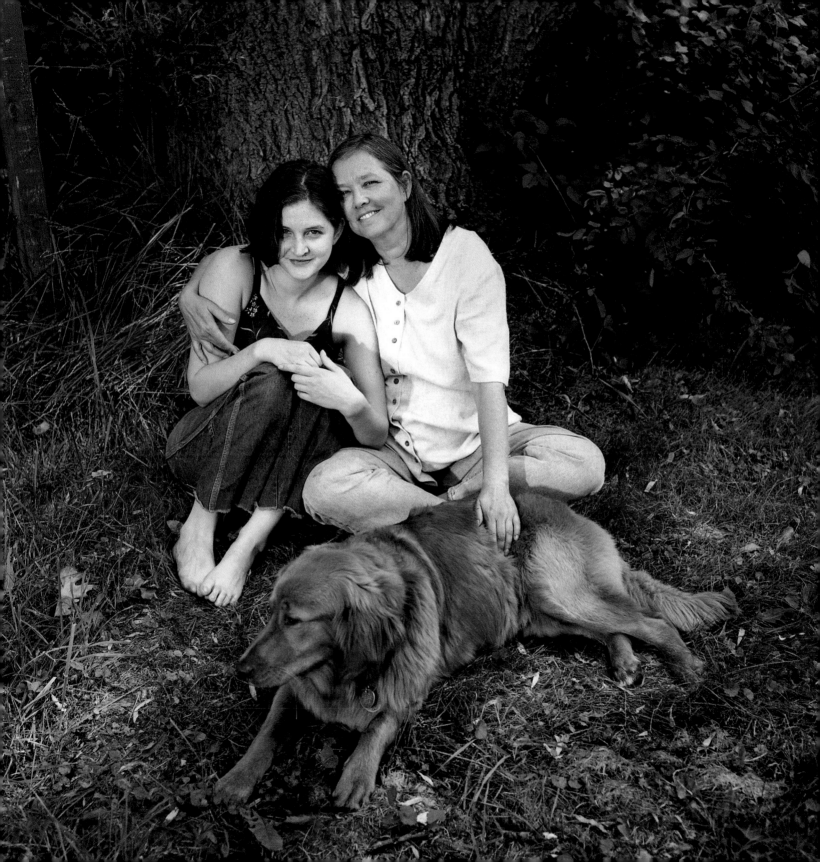

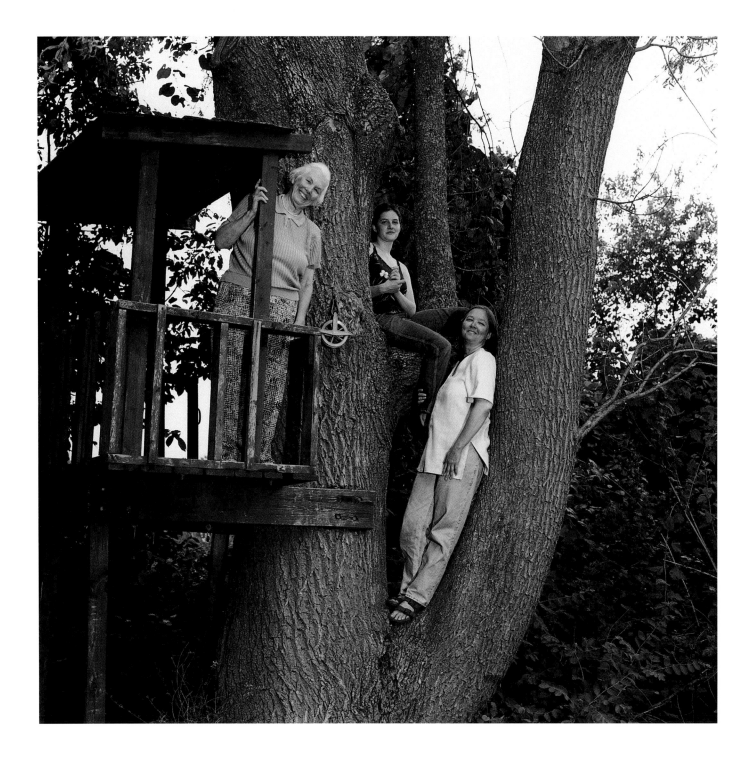

the average bear. She did give me a lot of permission to be whatever I was going to be. Even now I start to get glimpses of, "Oh! I could do that down the road." It feels like there's doors and doors that could be opened. Still and forever.

JULIE My mother would always say, "Fools rush in where angels fear to tread, but let's go ahead and try it anyway." I tried to give Didi that same permission. It was a lot of fear for me when she was growing up because the sixties were very different from anything I'd ever known. But I let her find her way.

DIDI The most difficult lesson I've had to learn is that I can't save anybody. I'm in a twenty-one-year marriage now, and my husband is struggling with a chronic illness. I want to save the children, to save my husband, to save my clients. I can do lots of things, but I can't save anyone. I think the first time I really got that message was when my son would go off somewhere and I would say, "Be careful, wear your seatbelt!" But the bottom line was, I was saying to him, "Don't die." Now he's working as a wilderness explorer. If anything's going to kill him, he's there. So I just say to him, "Don't die," and I also understand that I can't save him.

SARAH My mother's goal is to get to the point where if one of her children died, she could survive it emotionally. She spent a long time doing that for my father. It doesn't mean she closes people off from her; it's kind of a Zen thing.

JULIE The main thing I've learned from Didi is that people have to suffer through their own pain. My idea was that Mommy could make it right, and I tried very hard for years. But then I learned that wasn't the way. You have to go through it.

DIDI To me, being a mother means creating a holding environment for this other being to thrive in—like you would in a garden. It's about making the right soil, noticing that child's gifts. You get what is different about this kid. And then give space for it.

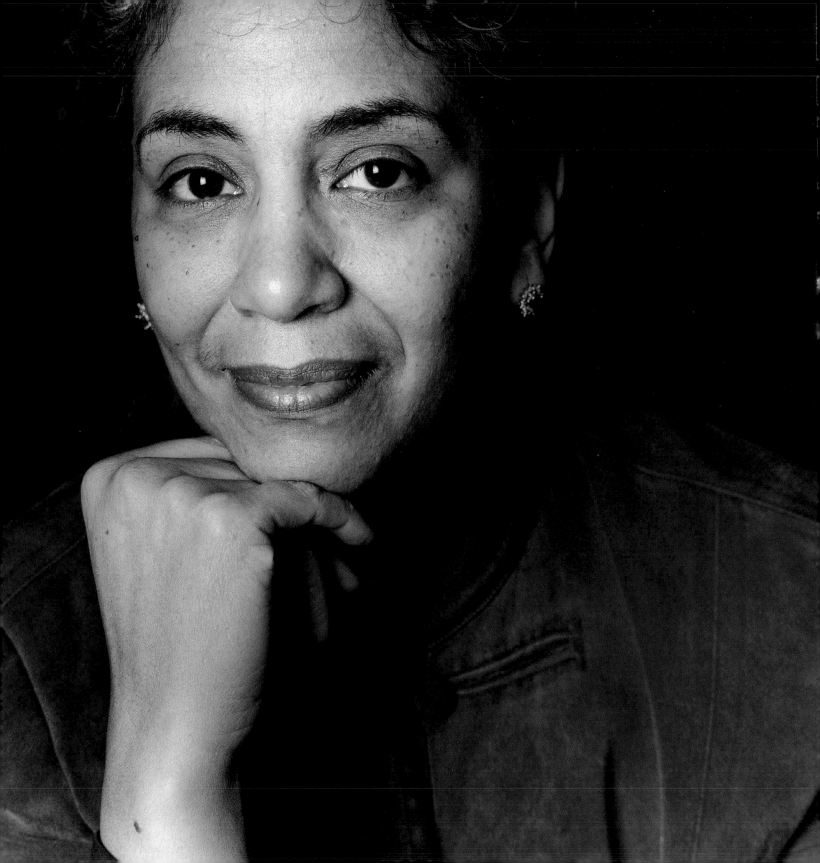

"I met something that could have destroyed me. I have been sucked out and put back in."

LYDIA THOMAS, 1933

DEVORAH FONG-RIFKIND, 1953

RISA JAZ RIFKIND, 1990

Risa Rifkind is smart, sensitive, fresh, and, at the age of eight, smaller than her four-year-old brother. She is a child who was born with dwarfism, and every day she deals with physical challenges—including a fragile spine—at a school filled with average-size people. Her parents have immersed themselves in the Little People of America organization; they, along with her grandmother Lydia, are doing all they can to smooth Risa's way.

DEVORAH FONG-RIFKIND

I slept with my mother until I was seven. She bathed me, laid out my clothes. She was the authority, she was the knowing source from which all wisdom and arbitrary rules came, you know? But she is someone who I consider a real friend and a lot of fun.

When Steven and I were married it was a great ceremony, a beautiful mixture of cultures, if I do say so myself. We started trying to have babies right away. I became pregnant with Risa and it was marvelous. I was huge. I was healthy. My hair was shining. No one had ever been pregnant before, you see.

In my seventh month I was so large that we went through a series of sonograms until we received the diagnosis that the baby was going to be a dwarf. I had been carrying her around for almost thirty weeks. We were moving together. We had named her.

There are over eighty different types of dwarfism, and some types are incompatible with life. So we went through months of torture and eating a lot of ice cream.

We started going to Little People of America meetings when she was maybe two, so she has seen little people and their parents and siblings.

One of the biggest fears was, what do I tell Risa when she says she doesn't want to be a little person? Well, it's come up several times. The first time she asked I got this gut-grabbing wrench, and I said, "Well, why not?" as calmly as I could. She said, "Because I can't reach things." And then I said, "Well, let's see if we can make it easier for you." And you realize you don't have to reinvent the wheel. There have been little people since the beginning of time.

I don't think that there is a god who sits there and decides, "Oh, Devorah and Steven can handle this, so we're going to send them this child." It's just the lottery. All of a sudden this child is there in the incubator, and what are you supposed to do but nurture that child?

117

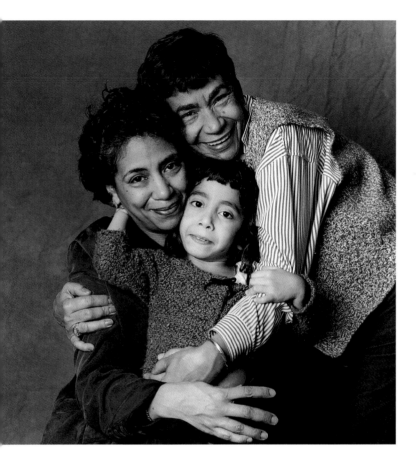

Unless you have a child like this who shows you what your depth of feeling can be, you don't know it. Now, is it something that I wish upon you? No, but you find out how profound your love can be. I have a bright, sensitive daughter. She's fresh and rude and everything else, but she is incredibly insightful. No, I don't want her to be a dwarf because she's hurting. You always want to fix this hurt for your child.

I've survived these last seven years. I met something that could have destroyed me. I have been sucked out and put back in; I met the devil, I met something that for me changed a level of anger, changed a level of love, changed everything. And my greatest achievement is that my daughter is who she is and my son is who he is.

LYDIA THOMAS

Dev's pregnancy started normal, and then she came to the house one day and she was a valley of tears. It was so shocking. Nature called the game on us. I cried and I prayed for her to have the strength to handle this.

But when Risa got here, that girl was a movie star. It was flowers, flowers, flowers, and gifts came in from all over. And she was our baby, cute as a button and smart. Devorah and Steven are just lucky in their own fashion, I guess.

ABOVE *Clockwise from top: Lydia Thomas, Risa Jaz Rifkind, Devorah Fong-Rifkind*

PAGE 116 *Devorah Fong-Rifkind*

I was born in Panama. My father had a nice home. We had cooks, laundresses. My mother was very poor, so he elevated her lifestyle, but it just didn't work out between them. She brought us here when I was fourteen or fifteen. I hated it. We had learned English, but I would not speak. I wanted to go home. I lived in the Bronx with my grandmother, and I was used to being with my father, boating and swimming. But I got married, I got divorced, I got my degree, I supported three kids, it didn't kill me.

They have a saying in Spanish, *El Paño de Maria*. It means that the shelter of a mother's arms is where the child goes for hope, love, comfort, and salvation. It's, like, holding them up so that whenever they drop, even if they're old, you're there for them. Because you never stop being a mother. You don't outgrow it.

RISA JAZ RIFKIND

I like to climb and dribble. And swim. That's it. And play in the snow.

When I was in second grade, Mommy told me that other little people, about my age now, they don't want to be little people, but they just have to get used to it. I don't like it, but we have to deal with it. My brother's taller and he helps me get things and I like that. Sometimes he's a pain.

Mommy can still pick me up. But one thing I really love is I get to go in small places. I think that I'm a little faster than average-size people. My friend and I were playing follow the leader; I went under this small place and Ashley couldn't get through and she had to go through the big place.

I want to have twins, a boy and girl. I want to have average-size people. I'm full of ideas of what I want to have.

Risa Jaz Rifkind

"I didn't have a role model in sports, but I had role models in my home."

RUTH HARDY, 1922

RUTHANN LOBO, 1944

RACHEL LOBO, 1971

REBECCA LOBO, 1973

Seconds after the winning point was scored in the final game of UConn's undefeated 1995 season, Rebecca Lobo ran blindly across the court with her arms wide open, looking for someone to hug. It was an unforgettable moment, not just for its emotional impact, but because, for the first time in history, women and girls had a basketball hero to call their own. Rebecca has her heroes, too: her mother, with whom she wrote an inspirational book entitled The Home Team, *and her close, loving family.*

REBECCA LOBO

When I was a kid I idolized Larry Byrd. But there wasn't a single woman for me to look at and say, "I'm going to be just like her some day." I didn't have a role model in sports, but I had role models in my home. From my grandmother I learned that I could do whatever I wanted as a woman. She was the Ping-Pong champion. My brother was good, but he couldn't beat my grandmother. It didn't matter that she was a woman.

My mom and I were always really close. When she got breast cancer I realized that she wasn't going to be here forever. It really scared me, but she said, "It's going to be fine—you take care of your thing and I'll take care of mine." And then she's like, "You know, your dad's not a breast man anyway."

Our home always seemed to me like a safe place; no matter what was going on in the world there was always love and laughter and fun here. If there was ever a conflict, it was resolved immediately. Actually, Rachel and I probably still come home so often because neither of us has a washer and dryer!

RACHEL LOBO

The question I get asked the most is, "Do you ever feel jealous towards her?" Absolutely not. I couldn't be more happy and proud of her. There's so many things that I've gotten to do, people I've met, and I never would have been able to do them if she wasn't in the position she was in. Sometimes I see the things that she has to go through and I'm almost like, "I'm glad it's her and not me," you know?

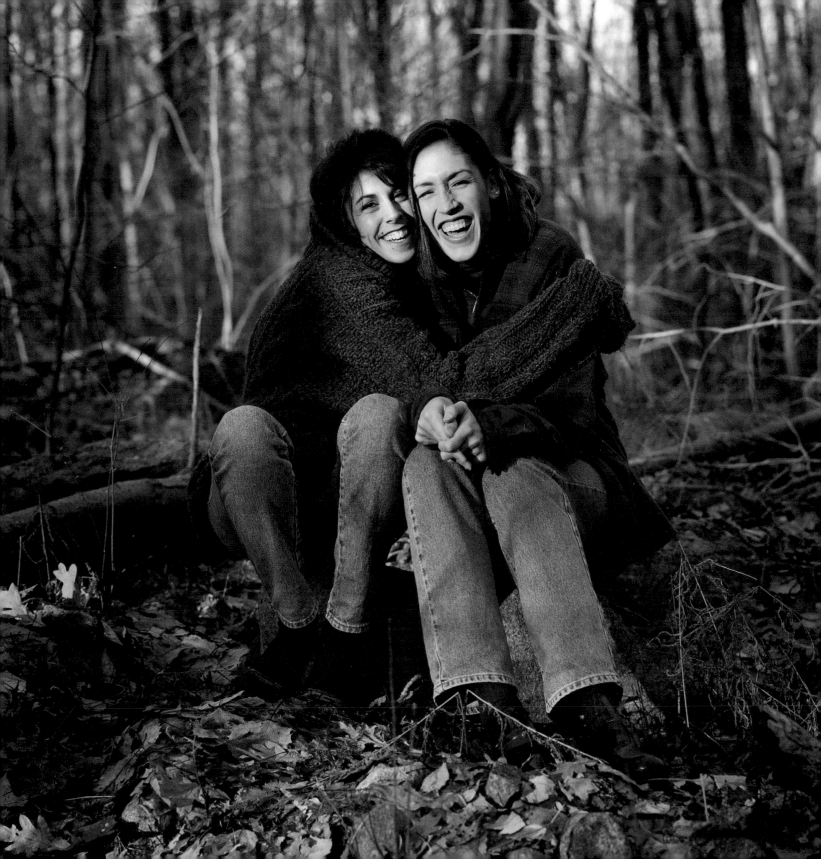

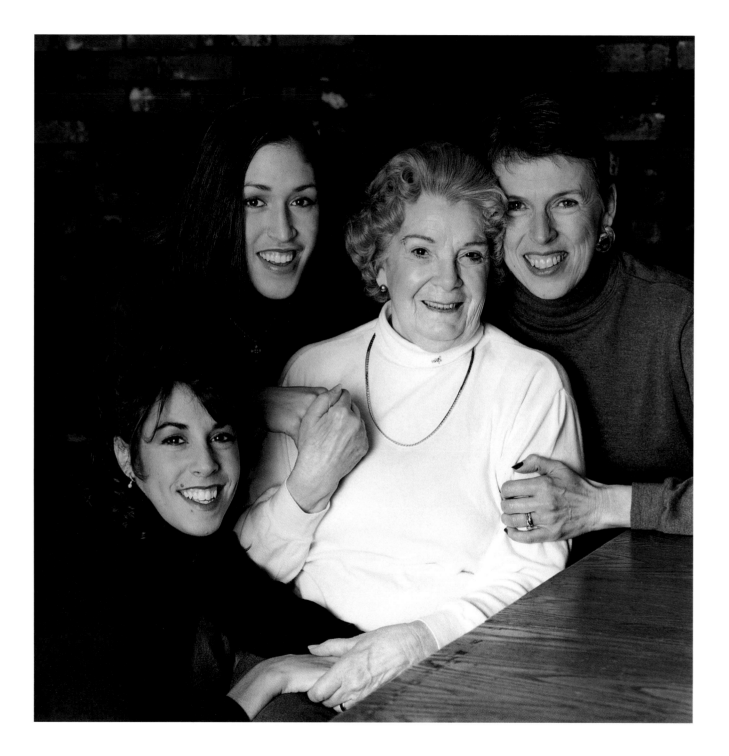

I think I could have spent more time with her when I was younger. But of course at that time I was like, "Get away from me, you'll ruin my image." In high school I was just glad that she was on my team. She scored her thousandth point in my senior year; I tried to give her the assist on that because I wanted it to be the sisterly thing.

RUTHANN LOBO

When I grew up, to be somebody was to be the cheerleader. I didn't make it. So I tried out for the basketball team. We were undefeated my senior year and I was MVP, but my kids probably inherited their athletic prowess from my mother. She's a very good athlete; she's still roller-skating with my niece and nephew.

My mother was the one who showed by example, seeing beyond how a person looks or what a person owns to their humanity. I have friends who have told me that she was the significant person in their life because they came from dysfunctional homes. When I was little, my friends would come over to see my mother instead of me!

When I look at my kids—Jason defends abused children, I watch Rachel interact with people, and if you saw the letters that some of these kids write to Rebecca, they'd blow you right out of the water—that's what matters. If Denny and I have been responsible for bringing three good people into the world, that's what parenting is for.

RUTH HARDY

I had nine brothers, one sister. My mom was so busy around the house that she didn't have much time for us, but she showed us how to be good to each other. We had nothing, but anybody that came to our house, there was a place for them at the table.

I never was in Girl Scouts, so when RuthAnn got old enough to be a Brownie, I joined up as a leader. I grew up with my children. What I didn't have when I was a child I got with them.

I hope I passed on a sense of love. We hate to see anybody hurt. If one hurts, we all hurt. If one's happy, we're all happy.

"I said, 'What I need is a year out of the convent. I'll get a job, and when I come back, I'll be real.'"

ANNE MARIE COFFEY,
1916

PATRICIA ANN GIGLIO,
1940

ANN GRACE GIGLIO,
1970

Patricia Giglio, a former nun, left the convent and married a former Christian brother. With help from her husband and her mother, a career nurse, she has raised a son and a daughter, Ann, who was born with developmental disabilities. Pat now teaches literacy and parenting in a men's correctional facility.

PATRICIA ANN GIGLIO

I wanted to be a nun since kindergarten. We lived in Brooklyn, in a very Catholic area. You identified where you lived by the parish you belonged to, not the neighborhood. My mom was a nurse, a wonderful role model. She reveled in her work, and yet was still a good mom, you know? I was always proud of her being a nurse; I knew it was something special.

There were three of us. I'm the oldest, my brother Jimmy is two years younger, and Kathleen is eight years younger. They had hard times when we were growing up, my parents; my father worked on the docks. And my mother really was the breadwinner, the strong mainstay of the family.

We moved to Staten Island when I was in the second grade, and we had the Sisters of Saint Francis. They were these bright-eyed farm girls from Wisconsin, and they were the most wonderful group of young women you'd ever want to meet. It just solidified that this is what I wanted to do.

In eighth grade I thought seriously about joining. But the Mother House was a thousand miles away, in Milwaukee. So my mother said, "Go to high school, and see if you really want to do this." At the end of my freshman year, my parents just let me go. I was fifteen. Now that I'm a parent myself, I wonder how they could've done it.

In those days they had what they called an aspirancy. Up at five in the morning, praying, working, scrubbing floors, and going to school. After a year, we started what they call postulancy. It's like boot camp. They're really tough on you, 'cause they want to be sure you aren't just in love with *The Sound of Music*. They were screening us out!

Then I did novitiate. That's when you wear the white veil and have practically no contact with your family for two years. If you want to be a nun, then you sort of marry God. I didn't even know who Elvis was in 1957! But I never wavered.

124

The second-year novitiate was our first year of college. I loved school. But after one year, I was out teaching second graders. The next year the principal asked me to teach eighth grade. So here I was, a couple of years older than my students. I was scared to death, but I loved it. Well, I got transferred to East 80th Street in Manhattan. Let's talk about going from these little kids in Wisconsin, who jumped every time you looked at them, to the city kids who had a completely different view of life. Most of them were from five-floor walk-ups. But we also had U.N. ambassadors' kids. It was great for everybody.

Well, now we're into the sixties. It was the time of Vatican II, Pope John XXIII questioning everything. The community I belonged to was on the forefront of change, reaching out to the poor. And this was also the time of the women's movement. These women were determined to free themselves of the—I don't care, quote me on this—the chains the church had imposed on them. So how do you do that and still remain a nun? Every moment of your life there was a rule. What time you got up, what time you went to bed, the kind of work you did. And everything had to be reinvented.

We were encouraged to get involved. No more hiding in the convent. Well, geez, I was fifteen when I entered, what did I know about the world? I got very depressed. Here I'm working with families with all these problems, husbands are drinking . . . I felt like a phony. So I said, "What I need is a year out of the convent. I'll get a job, and when I come back, I'll be real." So I got a job as a social worker for Catholic Charities in the South Bronx.

It was fabulous! I had an apartment, and I worked with unwed mothers and young people with drug problems, and I supervised home health aides. I was supposed to go back in September, and I just sort of never called. By this time I was almost thirty, and I had realized that teaching was my bliss. And, I wanted to start a family. So I went and signed the papers. I remember the monsignor was rigid—he was angry because I was happy. I guess he thought I should have been distraught. I just felt bad for him.

Charlie had been out of the Christian brothers for one week when I met him at a wedding. I was very Doris Day and, you know, very virginal, and he was just so kind. We started dating, then I went to Spain for three weeks, and when I came back he proposed.

Annie is just the joy of our lives. She was a very sweet, placid baby. She adapted well to anything. We didn't find out that she had developmental problems till she started kindergarten. We had her tested, and she's neurologically impaired. There were abnormalities; not real serious ones, but she walked slower, she talked slower. And then she

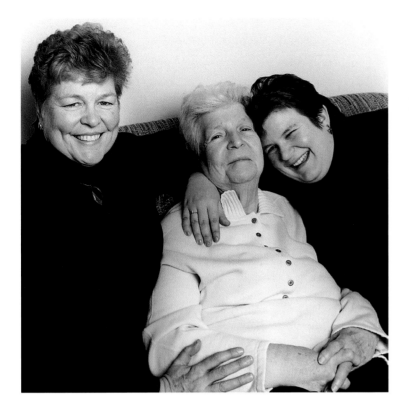

Left to right: Patricia Ann Giglio, Anne Marie Coffey, Ann Grace Giglio

developed a weakness on the left side of her body, so they think there might be a little cerebral palsy.

Tom was ten pounds, twenty ounces when he was born. Happy, macho kid. The only thing in life he doesn't like is school! Mother's a teacher, father's a principal. Why would he like school? But he got an athletic scholarship to college, and now he's a counselor with young adults with developmental disabilities.

My mom lived with us for seven or eight years when the kids were growing up. She was wonderful; she helped me a lot when I was working. Tommy is still very attached to her because of it.

Ann was in special ed classes, and then they mainstreamed her. In ninth grade, they said, "We'll see if Annie will graduate." And Charlie said, "Ah, no, change that. Annie will graduate, and what can we do to help her?" She graduated with an eighty-five average from high school. She's a fighter. I think she gets a lot of that from my mother—my mother is a person who won't take no for an answer. Annie got the award for the student with the most determination. It was a powerful moment for all of us.

I would say that five years ago I might have limited the dreams I had for Annie. Now Annie has proven to us that when she's determined to do something, she will do it. Oh, a lot of moments I was scared. What's going to happen when Charlie and I are no longer here to take care of her? What will she do socially? Now, she's earning a living, she has her own health insurance. Soon she'll be in her own apartment with another girl. I no longer put limits on Annie. She's never put them on herself. She's taught us to let her go. To be around, but to let her fly.

Last week Annie and Tommy took us out to dinner at a really nice restaurant. And Charlie and I both said, "This is the happiest day of our lives." These are wonderful young people. The greatest joy of being a mother is at the point where I am now, seeing what they have become. Maybe in spite of you? Because of you? I don't know. But I know that the world is a better place for them.

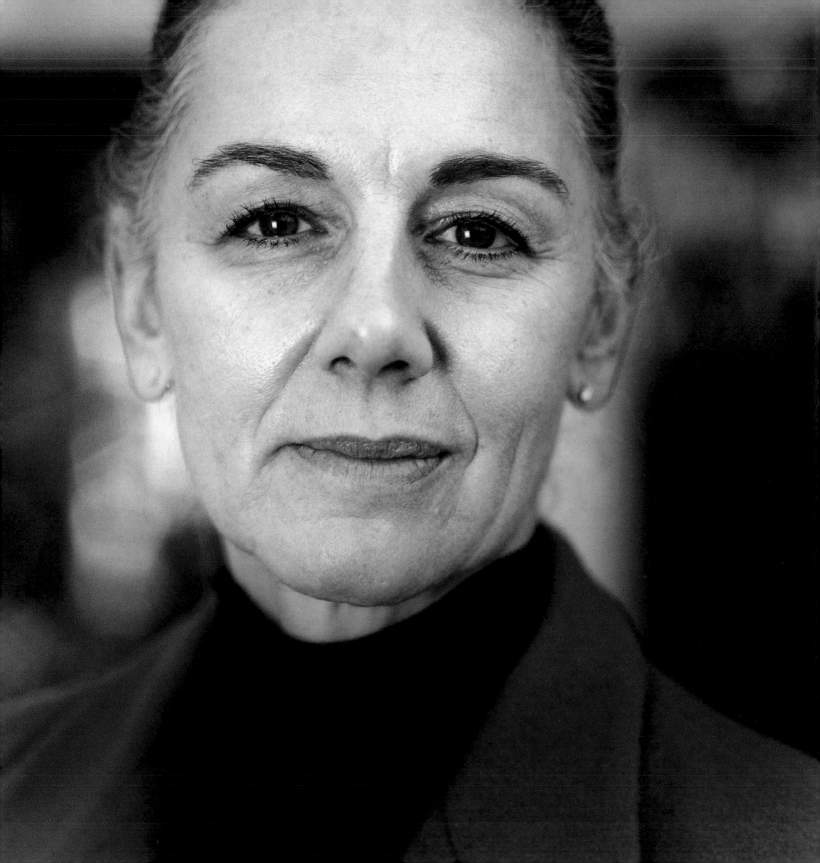

"I remember doubling over—
it was almost like birthing pains."

KATHRYN THEVOS, 1911

APHRODITE TSAIRIS, 1943

ARIADNE TSAIRIS, 1974

*Alexia Tsairis was one of
270 people killed by a terrorist's
bomb on Pan Am flight 103
in December 1988. She was
twenty, a promising young
photojournalist. Her mother,
Aphrodite, responded to the
tragedy by becoming an activist,
fighting for survivors' rights
and campaigning against
terrorism. The Tsairis family has
since set up a scholarship for
photographers whose work
promotes peace; the coveted
award is known as the Alexia.*

ARIADNE I was fourteen or fifteen, a freshman in high school. It was December 21, 1988. My sister was coming home from London, from a semester abroad.

APHRODITE The night before, she had called and said that we should all come to the airport to meet her because she had a surprise.

ARIADNE I was down at my grandmother's, we were watching our soap opera, and there was a news bulletin saying that a Pan Am flight from London to JFK had … they didn't say "blown up." It was very vague. I called my mom and said, "What flight is Lexie on?"

APHRODITE I just knew she was on that plane. And I remember doubling over— it was almost like birthing pains. That pain would come back to me periodically over the first couple of years.

ARIADNE The next report had pictures of ambulances and fire trucks in Lockerbie, Scotland. We didn't know what to do or who to call. Finally, my father and brother came, and by that time it had been announced that all two hundred and seventy people on board had died. I remember going upstairs, huddled in my bed with the pillows over my ears. I remember my grandmother asking, "Why, God?" And from then on it seemed like a big blur. A lot of people in and out of the house, a lot of crying, a lot of unanswered questions.

APHRODITE For fourteen days we didn't have Alexia's body. There was a vigil here, and the older members of my family didn't want any pictures of Alexia around. But I dug out every picture that I ever took of her. It was confronting it, putting it out there. And it served the purpose of having her spirit with us.

ARIADNE Her body came back in a crate. We arrived at the airport, it was just us, and my sister's body was unloaded. . . . It was amazing to me—you know, do these people have any feelings whatsoever? My God, we actually showed up in the cargo area . . . the non-caring was shocking.

APHRODITE The crate in which she was returned had come with a warning: "We recommend that you do not view the body." But I thought, "This is my child. I really need to see my child." There was so much pressure around me . . . I decided to have photographs taken. There was one of her face, and I remember touching the photograph and saying good-bye. So that led me to a mission, and I convinced the Scottish police to change their policy about releasing autopsy photographs, so that those who wanted to view their loved ones would have the chance.

ARIADNE There's this thing that people do when bad things happen. They don't tend to talk about it. But my mom made it an issue to talk about Alexia—little things, so she was never very far away. She was constantly being brought into the conversation, so we would feel more comfortable in dealing with this. And not keep it inside. And that was a large part of what my mom did for all of us.

APHRODITE I've lectured, I've gone to Washington. We worked for changes in airport security, we've fought against terrorism. I'm still very active in the victims' group. And that was how we got through it as well.

ARIADNE When I look back on what my mother has done, it's incredible. Politically, emotionally, everything. I mean, she jumped right in there. . . . The first five years were intense. Pan Am 103, Pan Am 103. It was in the news, it was in our home all the time.

APHRODITE In the heat of all the activity, I always took time off to walk to Lexie's place. I buried her two miles from here. I would sit there and read poetry to her, or just sit. I try to keep that focus: I'm doing this because I lost my child, and if I can make this better for somebody else, then I have served her memory well.

Alexia was a photojournalist; her surprise from London was that she was given an award. So we established an organization for photographers whose work promotes

cultural understanding. It's known as the Alexia Foundation for World Peace. It is our life's work.

When this first happened, I thought I wanted to be eighty so I would die soon. But somehow when you're so violated, so hurt, you get strength. Does God provide that? Is it Alexia that's guiding me? I like to think that she's somehow there. I like to think of it that way.

Left to right: Kathryn Thevos, Ariadne Tsairis, Aphrodite Tsairis

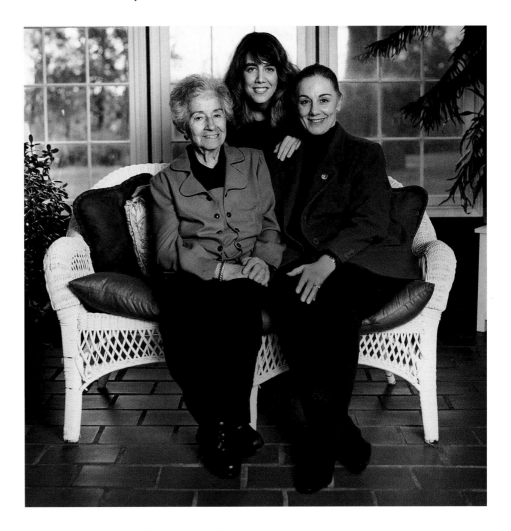

"Any children that want to participate, they do. I don't care what their status is. There's no stigma, no segregation."

MARIE KRAUSE, 1920
BRENDA EHEART, 1944
SARAH EHEART, 1975

Hope Meadows, located on a former military housing development in Illinois, is the first planned community of Hope for the Children; its residents are legally obligated to take care of the children who live there. More than a dozen foster families, many of whom also have birth children or adopted children, live there rent-free. The rest of Hope Meadows is occupied by senior citizens who befriend all the kids. The nurturing neighborhood is the brainchild of Brenda Eheart, who herself is mother to an adopted son, Seth, and a birth daughter, Sarah.

MARIE KRAUSE

Brenda and I always had a close relationship. It just came about naturally. We have a number of things in common—clothing and sewing, cooking. I was not the ideal farm wife, though. I started college but dropped out, and my husband probably would have been a good college candidate, too. We wanted our kids to have a broader life, to stretch their horizons, to become more independent. Brenda said we always encouraged them to move, and I guess we did because they're coast to coast and in the middle.

I just think it's remarkable that she got the idea for Hope Meadows and was able to carry it through. I think the concept is great, especially the intergenerational thing. She said she's stubborn, and I guess that does run in the family; just to get these buildings from the government was a major achievement. But I don't think of us as being special. Maybe Brenda's special because of what she's accomplished, but my goal when they were growing up was to hold the family unit together.

BRENDA EHEART

I had the original idea of getting twelve or fourteen houses where foster families could really support each other and have some staff that could support them as well. That was born out of my research in which I found that foster families weren't doing well with their existing resources. They really needed this kind of help.

It took years of major struggle to get the money and to fight the Pentagon to release the military housing for the project. Well, when the property finally came available, I had to buy it all. So I said, "My God, what am I going to do with eighty-four houses!"

A friend dragged me to hear Maggie Kuhn, founder of the Gray Panthers. And what an inspiration she was! I said, "That's it. We're going to put seniors in those other homes. We're going to give them reduced rent and they're going to give us volunteer

133

ABOVE *Brenda Eheart*

PAGE 132 *Brenda Eheart, seated in the center, surrounded by residents of Hope Meadows*

time." I had no idea—they are obligated to give us six hours a week, but we get ten, fifteen. And well, these kids come so profoundly neglected. The seniors, they call to the kids and put their arms around them. Our seniors *love* these kids.

People are concerned about black children's racial identity. Am I worried? No I'm not. Our black kids are going out there with the white seniors, they are changing the way these people think! I mean, it is phenomenal.

And then again, it becomes a reflection of what I did in my family. I grew up on a small dairy farm, and I did all the traditional things that girls did in the fifties—clean the house, collect the vegetables, work alongside my mother. I met my husband in 1968, when every time you turned around somebody was assassinated. I ended up working in child welfare, and went into inner-city Chicago. I probably learned more in that six months than I did in my whole college education.

My husband and I knew that we were going to adopt children. We went to Ecuador on our honeymoon and we fell in love with all these Inca children. We had started the process of adopting Seth, who was from Peru, when I became pregnant with Sarah. Was there a difference between raising an adopted Inca and a blue-eyed biological daughter? I can tell you there was no difference.

That's what we want here. This building is abuzz with activity. We've got a computer lab downstairs, the library upstairs, tutoring rooms, and any children that want to participate, they do. I don't care what their status is. There's no stigma, no segregation.

I don't know where this passion for kids comes from. I love my own two kids, but I've always worked with adults; you'd never see me working in a grade school. But I can't stand to see children being vulnerable and hurt.

My daughter always said to me, "I can't do what you're doing, it's too depressing." Now she's in a Vista program, she's coordinating seniors, reading to low-income children, she's doing English as a second language, a crisis hotline for teens. Everything she's doing is leaning this way.

SARAH EHEART

Through college I was debating whether I wanted to do what my mom does. With speech communication, a lot of people go into human resources. And so I did explore that, and I hated business in general. And then I had a mediation internship at the juvenile courthouse, and what I liked most was mediating between delinquents and their parents. So I slowly started falling into Mom's line of work. She'd listen to me and laugh and say, "You sound just like me."

I have a good friend in California who is making tons of money. I went to her office Christmas party and these people are in their Armani tuxes and their Versace dresses and I was just, "Oh, I don't like this. There are so many homeless people that could be using this money."

I volunteered at Hope this past summer and I loved it. I think I like working with the kids more than Mom. She likes to see the whole big picture and I like to work with the kids.

What she's done is incredible. This all started when I was in high school and I didn't pay much attention to it. And then my sophomore year in college I came to the open house—that's when it hit me. To see the families and kids, to actually see it working, it's just so cool. I think that's where my interests are.

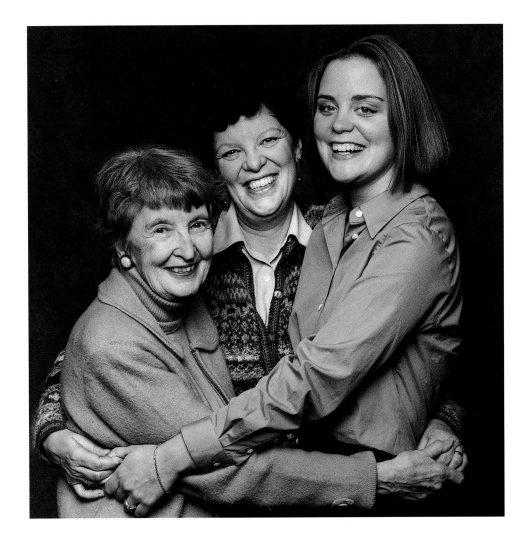

Left to right: Marie Krause, Brenda Eheart, Sarah Eheart

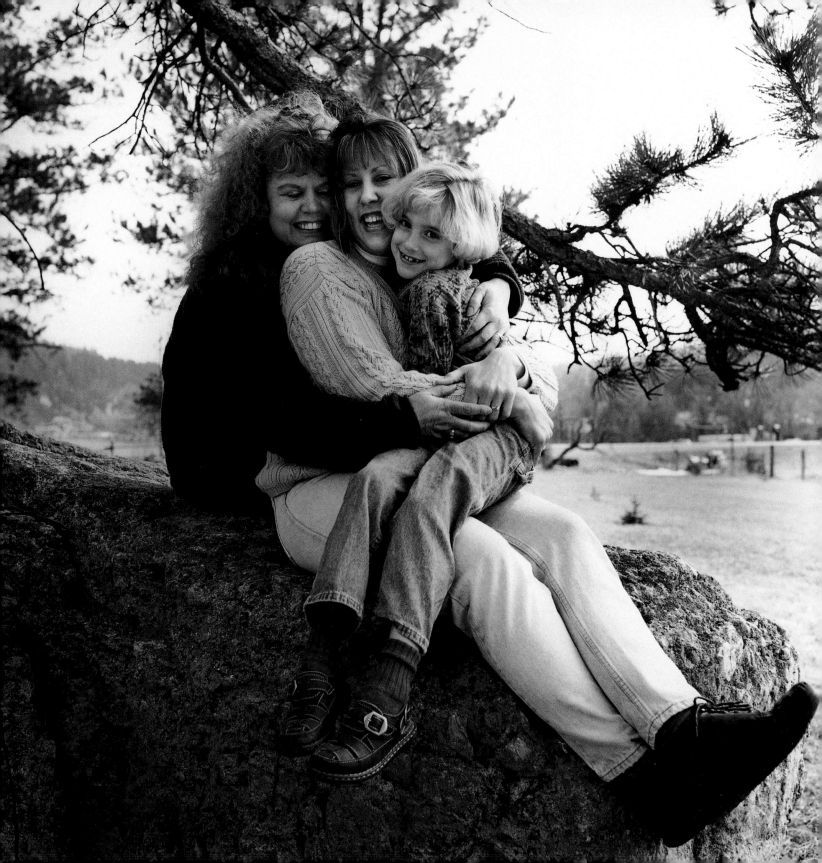

"When you have a child that's hurting, you want to fix it, right?"

ARLETTE SCHWEITZER,
1948

CHRISTA MARIE UCHYTIL, 1968

CHELSEA ARLETTE UCHYTIL, 1991

Arlette Schweitzer made national headlines when, at the age of forty-two, she carried and gave birth to her daughter's twin babies. What seemed outrageous to the rest of the world was, to Arlette, a completely natural act: she had done something her daughter couldn't and, in doing so, increased her own happiness twofold.

ARLETTE SCHWEITZER

When Christa was fourteen years old, she had not yet menstruated. She went to the doctor, and I didn't even go with her. But the doctor called, and we met her at the hospital. That's when we learned that Christa had Rokitansky-Küster-Hauser-Mayer syndrome. She was born without a uterus.

This was just tragic, a terrific blow, because Christa's true vocation in life was to be a mother. I knew that. We conferred with a specialist and learned that, fortunately, she did have healthy ovaries. I said to the doctor, "Can you transplant my uterus into her? I'm never going to use it again." He said, "How old are you?" I was thirty-seven at the time. And at that minute it was as if a light went on. Christa looked at me and I looked at her and we knew that someday I would carry a child for her.

At that time it hadn't been done. But I prayed that medical technology would move along fast enough so when Christa was ready to have a child, I could do it.

Danny and I have known the pain of losing a child. People that long to have children have a similar grief. Christa was certainly grieving. And once we had made that decision, I just believed with my whole heart and mind and soul that it would work. And if it didn't, then it was God's will.

I was fifteen when I got married. I loved every second of it—playing house, making dinner, dressing our little boy. When Christa was born, I felt we were being blessed over and over. Then our third child was born. Christa was four, Curtis was in kindergarten, and when Chad was four months old he died of Sudden Infant Death Syndrome, and that's when my fairy-tale world came falling down.

I knew I would never have another child. I had my tubes tied. I became a very protective mother—truly neurotic. If my children were five minutes late I wanted to ground them. But Christa deserved her chance to have a child and so it was easy for

PAGE 136 *Left to right: Arlette Schweitzer, Christa Marie Uchytil, Chelsea Arlette Uchytil*

FACING PAGE *Chad Daniel Uchytil (left), Chelsea Arlette Uchytil*

me to make that decision. I didn't look at it any differently than giving her a kidney. When you have a child that's hurting, you want to fix it, right?

I came full circle in many respects, and it felt good. You know, this Chad and this Chelsea heal a lot of wounds. Not only for Christa but for me. I never had a flickering doubt of, "What if …" I never had one sweaty moment.

I always look at the end result first; I did everything a little bit backwards. When my friends were worrying about proms, I had kids. I went to college when I was a grandmother. And when Chad and Chelsea were born I was forty-two. It was just a miracle.

CHRISTA MARIE UCHYTIL

Like all little girls, I played house and had dolls. I always said, "I want to be a mommy." I think a lot of that is because I loved my mommy very much.

I trusted her completely. When I was fourteen and had the ultrasound, I only had an hour of real terror because on the way home Mom convinced me that everything was going to be okay. It wasn't worth worrying about and that was it. I don't have a horrible story, I didn't spend years suffering, because I truly believed my mother.

People have said to me, "Poor you," and I say, "I have an awesome husband, I have awesome parents, I have awesome kids." My sister-in-law teases me: "Poor you, right. You don't have the monthly thing and you don't have stretch marks from here to here."

My mother would do anything for me, and my big worry was that she'd have horrible labor pains. When her water broke, Dad and I ran around the house asking Mom what we should do. Even in labor she was comforting me! When the babies were born and they said, "It's a boy, it's a girl," I didn't want to leave Mom's side. And then she said, "Christa! Don't stand there, go see them!"

Now they're Kevin's and my life. I don't know how to sum that up except in words like *happiness* and *completion*. We know in our hearts that it was right. It's gone full circle.

Acknowledgments

AMERICAN ASSOCIATION FOR LOST CHILDREN

BEST BOOKINGS AGENCY

CATHEDRAL OF THE IMMACULATE CONCEPTION

CHOIR ACADEMY OF HARLEM

HEART OF FLORIDA GIRL SCOUT COUNCIL

HOPE FOR THE CHILDREN

IN A FAMILY WAY

LINK ENTERTAINMENT

LITTLE PEOPLE OF AMERICA

LOLA'S HOT & FLYING TATTOO PARLOR

LYRIC OPERA OF CHICAGO

SAFE (SELF-ABUSE FINALLY ENDS)

WE ACT

WHITE DOG CAFE

I thank, with all my heart, my husband, Jacques Borris. Traveling around the country for this book meant leaving him with two girls to make dinners for, the little one to bathe, read stories to, and fend off the scary stuff under the bed for. As much as I learned from the women I met, from Jacques I learned how to help someone with the utmost grace. He never complained—not once. I thank Christina Kelley for traveling

all over America with me, often taking crazy flights in the middle of the night after driving and working long hours so that I could be back home when my children woke up. I could not have had a better traveling partner for this project. I left her sitting in many, many living rooms with people whom she did not know, while I interviewed others for hours. She handled herself beautifully in all respects, and I admire her greatly. While I was on the road I was able to leave my daughters in the care of our baby-sitter, Fiona Reilly. Whenever I called home, there would be laughter in the background and music blaring on the stereo; she could not have known how much I appreciated that. I want to thank the women in my life, Barbara von Schreiber and my sister, Kate Mercer, both of whom showed me that raising a daughter can be a marvelous and rewarding experience. I am always struck by how much their daughters love and respect them. Kate has taught me a great deal throughout my life; naming my daughter Mercer to honor her family was one of the best things I ever did.

Laura Straus had the idea that this project, which began as a documentary film I directed, should become a book. I am eternally grateful to her for that. My editor, Jacqueline Decter, taught me a great deal during the course of making the book. Her understanding of human nature and ability to deal with others is stunning. She guided me when I was lost and supported me when I was so in need of encouragement. It was an honor to work with her on this book, which is so clearly of my heart. When Patricia Fabricant showed me the layouts of the book they took my breath away—she performed magic with the design. Todd Lyon was able to get to the core of what I wanted to say, funneling the words and capturing the spirit in a way that amazed me. Her gift for words is profound and I am so lucky that I had the opportunity to work with her on this project. Cynthia Lyon was my lifeline. She was the first to hear the interviews and react and respond and let me know that my quest was not just of personal interest but had the capacity to evoke thoughts in others as well. I thank Bob Abrams for listening, keeping an open mind, having faith in me, and letting this book become what it is. I would also like to thank for their support and encouragement: my parents, Mr. and Mrs. Joseph L. Jones; Ann Egbert; Jonathan Pillot; Hiro; Neal Slavin; Stewart Cheifet; Melissa Chimovitz; Dennis Lee; Kathleen Stenson; Marlene Marino; and Kathy Grove.

The compassion of everyone who has been involved in *The Family of Women* moves me. I thank you from the bottom of my heart for this opportunity to explore, learn from, and celebrate these remarkable women.

Index

(Page numbers in *italic* refer to illustrations.)

Alexander, Patricia Ann Seymour, 65, 66, 67
Alexander, Sarah Jane Griffin, *104,* 106
Allegretta, Lillian, *18*
Anthony, Christine, 34, *36,* 36-37

Begay, Mary Lee, 93-94, *94,* 95, *95*
Bena, Anne Capozzi, *42,* 43, 44-45, *45,* 46
Bena, Rosine Anne, *42,* 43, *44,* 44-46
Bond, Gwen, 14, *15, 16,* 16-17
Bottando, Laverne, 76, 78
Brous, Marjorie, 60-62, *61, 62,* 63

Caswell, Nancy Alexander, *104,* 106, 107
Coffey, Anne Marie, 124, 127, *127*
Collier, Lucy Anne Griffin, *104,* 105, 107
Cooper, Marilyn, *98,* 99
Cooper, Shawne, 96-99, *97, 98*

Das, Biva, 68, *70,* 70-71
DasGupta, Sayantani, *69,* 70, 71
Dasgupta, Shamita Das, 68-70, *69,* 71

Eheart, Brenda, *132,* 133-34, *134,* 135, *135*
Eheart, Sarah, 133, 134, 135, *135*
Esperian, Aurora, 109, 110, *110,* 111
Esperian, Kimberly, 109, 110, *110,* 111
Esperian, Lola, *108,* 109-10, *110,* 111

Firman, Dorothy ("Didi"), 112-15, *113, 114*
Firman, Julie, 112-15, *114*
Fleming, Renée Lynn, *64,* 65-66, 67
Fong-Rifkind, Devorah, *116,* 117-18, *118,* 119
Forman, Linda, 85-86, *86,* 87
Fort, Marisa R., 88-90, *89*

Giglio, Ann Grace, 124, 126-27, *127*
Giglio, Patricia Ann, 124-27, *125, 127*
Golden, Evelyn ("Effie"), *30,* 31-32, *33*

Goldman-Steinman, Debra, 31, 32, *33*
Graitzer, Esther, *86*
Grier, Renee, 22-25, *23, 24*

Hardy, Ruth, 120, *122,* 123
Harris, Harriett Griffin, *104,* 106, 107
Harrison, Barbara, 40-41, *41*
Heaney-Grier, Mehgan, 22-25, *23, 24*
Henderson, Lenah Lee, 93-95, *95*

Jackson, Nicole Elise, 56, *58,* 58-59
Josephs, Caren, *84,* 85-87, *86*
Josephs, Sandy, 85, *86,* 86-87

Kealy, Christine, 100-103, *101, 102*
Kealy, Courtney, 100, *102,* 103
Keenen, Lucille, 100, 102, *102,* 103
Krause, Marie, 133, *135*
Kuzlik, Anna, *18,* 19-20, *21*
Kuzlik, Ilona ("Loni"), *18,* 19-20, *21*
Kuzlik, Kristina, *18,* 19-20, *21*
Kuzlik, Linda, *18,* 19-20
Kuzlik, Melinda, *18,* 19-20, *21*

Laybourne, Emmy, 14, *15*, 17

Laybourne, Geraldine, 14, *15*, 17

Lobo, Rachel, 120-23, *121, 122*

Lobo, Rebecca, 120-23, *121, 122*

Lobo, RuthAnn, 120, *122, 123*

Matteson, Cynthia Lynn, *104*, 105, 107

McArdle, Jill, 76-79, *77, 78*

McArdle, Nancy, 76, *78, 79*

McLaury, Rosalind Clare ("RaRa"), 88, *89*, 91, *91*

Morrison, Barbara Ann, 73-74, *75*

Morrison, Cosina Nashea, *72, 73*, 74, *75*

Morrow, Laura, 56, *57, 58*

Mulcay, Laura Frances "Sweetmama," *104*, 105, *106*, 107

Mullins, Aimee, 34-36, *35, 36*, 37

Mullins, Bernadette, 34, *36*, 37

Nelson, Beatrice Ann, *23*, 25, *25*

Nez, Grace Henderson, *92*, 93, 94, 95, *95*

O'Steen, Tami, 39-40, 41, *41*

Pettit, Alexandra Kate, 60, *61*, 62, 63, *63*

Pettit-D'Andrea, Suzen, 60, *61*, 62-63, *63*

Pillot, Maia Cooper, 96-99, *97, 98*

Reif, Anne, *98*, 99

Rifkind, Risa Jaz, 117-18, *118*, 119, *119*

Saar, Alison Marie, 27, *28*, 28-29

Saar, Betye Brown, *26*, 27-28, *28*, 29

Saar, Lezley Irene, 27, *28*

Saar-Cavanaugh, Tracye Ann, 27, *28*, 28-29

Schlosser, Grace Wicks, *80*, 81, 82-83, *83*

Schweitzer, Arlette, *136*, 137-38

Shenker, Evelyn M., 60, *61, 62*

Shepard, Evelyn, 56, 58, *58*

Shepard, Peggy Morrow, 56, *57, 58*, 58-59

Slawski, Sarah, 112-15, *113, 114*

Spear, Alison, 88, *89*, 90-91, *91;* Carolina, daughter of, *89, 91*

Spear, Laurinda, 88-90, *89*, 91

Spear, Suzanne ("Sue"), 88, *89*, 90, *90*, 91

Steinman, Reanna, 32, *33*

Steinman, Rebecca, 32, *33*

Steinman, Tamara, 32, *33*

Stepanski, Taron, *38*, 39-40, 41, *41*

Stevenson, Tasha, 48, *49*, 51

Stevenson, Tavia, 48, *49*, 51

Stevenson, Tonya Jan, 48, *49*, 51

Sweeney, Ann, 53-54, 55, *55*

Sweeney, Faith, *52*, 53, 54-55, *55*

Sweeney, Hope Ann, *52*, 53, 54, 55, *55*

Sweeney, Megan, *52*, 53, 54, *55*

Taylor, Mary Elizabeth Watson, 53, 54, 55, *55*

Thevos, Kathryn, *131*

Thomas, Lydia, 117, 118, *118*

Tsairis, Alexia, 129-31

Tsairis, Aphrodite, *128*, 129-31, *131*

Tsairis, Ariadne, 129-30, *131*

Uchytil, Chelsea Arlette, *136*, 137, 138, *139*

Uchytil, Christa Marie, *136*, 137-38

Weber, Ananda Bena, *42, 43*, 45-46, *47*

Wharton, Mary R., 73, *75*

Wicks, Betty, *80*, 81-82, 83, *83*

Wicks, Judy, *80*, 81-83, *82*

Youren, "Grandma Jan," 48, *49*, *50*, 51